DUTCH PAINTING

DUTCH PAINTING

Christopher Brown

The author and publisher would like to thank all those museum
authorities and private owners who have kindly allowed works
in their possession to be reproduced. Plate 32 is reproduced by
permission of the Trustees of the Wallace Collection.

Phaidon Press Limited
2 Kensington Square,
London W8 5EP

First published 1976
Second edition, revised and enlarged 1993
This hardback edition first published 1994
© Phaidon Press Limited 1993

A CIP catalogue record for this book is available from the British Library

ISBN 0 7148 3237 5

Printed in Singapore

Cover illustrations:
Front: Pieter de Hooch: *The Courtyard of a House in Delft*, 1658.
London, National Gallery (Plate 19)
Back: Frans Hals: *Pieter van den Broecke*, c.1633.
London, Kenwood House, Iveagh Bequest (Plate 8)

Dutch Painting

'We arrived late at Rotterdam, there was at the time their annual mart or Faire, so furnished with pictures (especially landskips and drolleries, as they call these clownish representations) as I was amaz'd: some of these I bought and sent into England. The reason of this store of pictures, and their cheapness proceed from their want of land, to employ their stock; so as 'tis an ordinary thing to find, a common farmer lay out two or three thousand pounds in this commodity, their houses are full of them, and they vend them at their kermesses to very great gains.'

John Evelyn, who visited the Rotterdam *kermesse* on 13 August 1641, was only one of the many seventeenth-century travellers to Holland who commented with surprise on the popular market in pictures. Peter Mundy, though lacking Evelyn's high-born conde-scension, remarked on the same phenomenon: 'All in general striving to adorn their houses, especially the outer or street room, with costly pieces, butchers and bakers not much inferior in their shops which are fairly set forth, yea many times blacksmiths, cobblers etc. will have some picture or other by their forge and in their stall.'

Although we may wonder as to the truth of Evelyn's very English explanation of the Dutch desire for pictures (he also attributes the vast expenditure of Genoese merchants on their palaces to a lack of land in which to invest), his account not only attests the existence of a thriv-ing trade in pictures: it also informs us that this trade was not confined – as in much of the rest of Europe – to the wealthy and the socially respectable. The artisan class bought and sold pictures, and these pic-tures were relatively cheap. It is worth enquiring how these conditions came about and, perhaps more specifically, what effect this popular demand had upon the kind of pictures produced in Holland during the century.

The Netherlands, the seven provinces centred on the economically dominant province of Holland (the latter included the buoyant city of Amsterdam), were enjoying a period of unparalleled prosperity in the early seventeenth century. One of the effects of the long war to gain independence from Spain, which was not formally concluded until the Treaty of Munster in 1648, was the northwards movement of the eco-nomic heart of the Low Countries. The Dutch blockaded the mouth of the River Scheldt, thus closing Spanish-held Antwerp's outlet to the sea. Antwerp's commercial supremacy then passed to Amsterdam, which became the economic centre of a nation which rivalled England as the strongest power in Northern Europe.

Dutch commercial prosperity, so bitterly defended against the English, does seem to have enriched not only the urban merchant class but a considerable number of the artisan class as well, and both social groups chose to invest excess capital in paintings. The demands of Dutch picture-buyers affected the kinds of pictures produced, and certain categories of pictures, such as Evelyn's 'drolleries', appealed

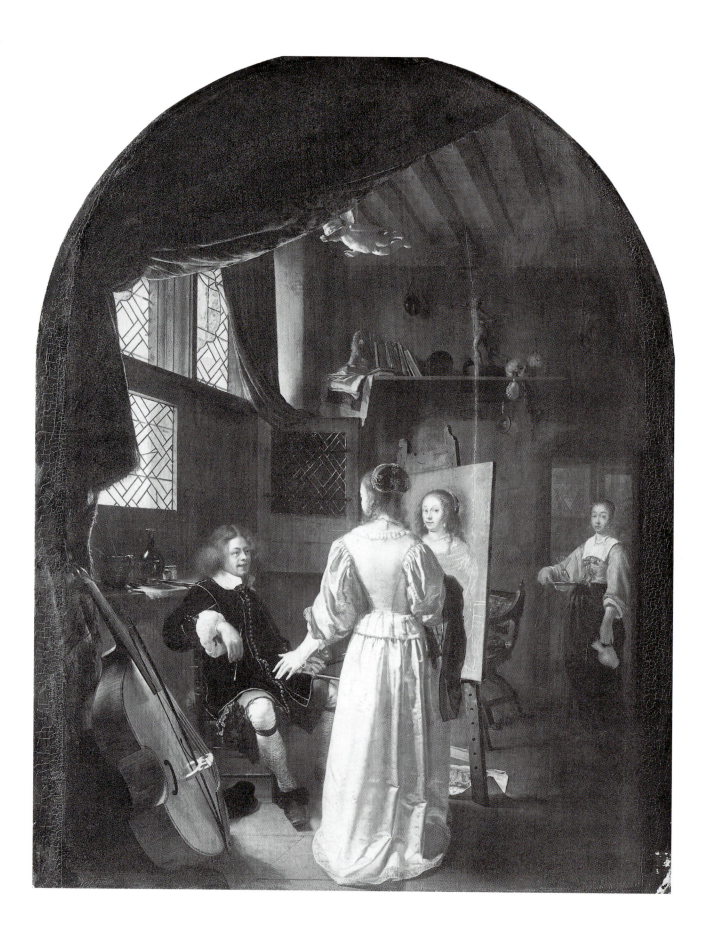

particularly to the tastes of artisans.

Portraiture is, of course, a kind of painting which we should expect to flourish in these social circumstances; and it is no accident that we know more about the appearance of the seventeenth-century Dutch than about any people until the Victorians.

One of the most influential commentators on the art of seventeenth-century Holland was Constantijn Huygens, the secretary of the Stadholder of Holland, Prince Frederick Hendrick of Orange. Between 1629 and 1631 he wrote an autobiography which reveals him to have been a humanist in the Renaissance tradition. He was a trained draughtsman and his remarks about contemporary painting are interesting and perceptive. Like many well-born Dutchmen, Huygens's outlook was European rather than narrowly xenophobic. He makes no distinction between painters in Holland and those in Spanish-occupied Flanders. The painter he admires above all others, 'one of the wonders of the world', is Rubens. Huygens shows himself to be familiar with the latest developments in Italian painting, praising the Carracci above Caravaggio. As for Holland, he recognizes the merits of the older generation of artists: Goltzius and Mierevelt are singled out for praise, though he thinks that the marine painter Hendrick Vroom has been surpassed by Jan Porcellis. 'The number of good landscape painters is so great that it would fill a book', he writes. Among them he mentions Esaias van de Velde (Plate 6), one of the founders of the Dutch school of realistic landscape, and his pupil, Jan van Goyen (Plate 7). Not only are the Dutch distinguished landscapists; there are as many history painters. He praises the Utrecht school of Caravaggio followers, including Hendrick ter Brugghen (Plate 1). It is a great tribute to the keenness of Huygens's eye that he singles out the young Leiden painters, Rembrandt and Jan Lievens, for special mention. Rembrandt, at this time only in his early twenties, is described as particularly skilled in the representation of emotions, whereas Lievens excels in bold composition.

When Huygens wanted his portrait painted in 1627, the year of his marriage, he turned to one of the most fashionable portrait-painters in Amsterdam, Thomas de Keyser (Plate 4). In 1633, six years after de Keyser painted Huygens, the retired merchant Pieter van den Broecke commissioned a portrait of himself from Frans Hals (Plate 8). The portrait, painted with all Hals's sureness of touch and strength of characterization, suggests a good-humoured, self-confident personality, an impression confirmed by van den Broecke's *Journal*, for the frontispiece of which Hals's portrait was engraved by Adriaen Matham. Van den Broecke had enjoyed a long and successful career as a merchant, first in West Africa and later with the Dutch East India Company in Arabia, Persia and India. For his loyal service to the Company, van den Broecke was rewarded with a gold chain worth 1,200 guilders, which he proudly wears in the portrait. Hals's evocation of character in bold, firm brush-strokes is quite unlike de Keyser's approach, with its careful accumulation of detail. Whereas de Keyser depends upon Huygens's environment to express his sitter's interests, Hals tells us about his sitter in his choice of pose and expression.

In his portrait of *Isabella Coymans* (Plate 25), Hals is at his most exuberant and Baroque. Her dress, with its low neckline, jewels, ribbons and bows, witnesses a liberation from the severe black and white of the traditional dress of the regent class, and must have horrified the older generation by its ostentation.

A portrait in a more serious mood, yet one which also contains a gesture which denies formality, is Rembrandt's *Agatha Bas* (Plate 14), painted in 1641. Rembrandt had come from Leiden to Amsterdam in

Fig. 1
FRANS VAN
MIERIS THE
ELDER
Self-Portrait
with Model
Oil on panel, 59.5 x 46 cm.
Formerly in Dresden,
Staatliche
Kunstsammlungen,
Gemäldegalerie
(destroyed in 1945)

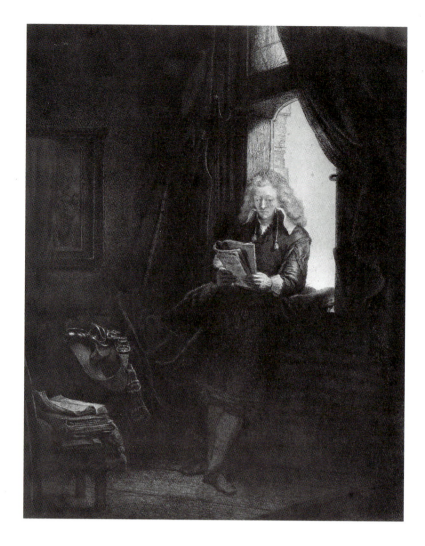

1631 or early in 1632, and was in constant demand as a portraitist in the city throughout the 1630s and early 1640s. His broad style super- seded de Keyser's almost miniaturist technique as the most fashion- able for portraits. Agatha Bas possesses neither Isabella Coymans's beauty nor her vivacity, and in technique the two portraits are very dif- ferent. While Hals's brush delightedly sketches the highlights of satin and pearls, Rembrandt lingers, exploring the varying textures, differ- entiating them in half-tones and closely observing the fall of light on them.

Rembrandt used bolder, more dramatic brush-strokes and richer colour in his portrait of *Jan Six* (Plate 24), painted in 1654. Jan Six was educated at Leiden university and in 1640 was sent on the Grand Tour, during the course of which he developed his interest in the arts. On his return, after initially working unenthusiastically in the family business, he began a career as a city magistrate, which culminated in 1691 in his appointment as burgomaster of the city. He was an avid collector of works of art, fluent in French, Italian and Spanish, and he wrote poetry. Rembrandt seems to have known him quite well in the 1640s and 1650s, and several other works by him are the products of this friendship: there is a portrait etching (1647; see Fig.2), an etched frontispiece for Six's play *Medea* (1648), and two drawings in Six's *Album Amicorum* (1652). Six lent Rembrandt 1,000 guilders in 1653 (an arrangement which was later to sour relations between the two men), and in the following year Rembrandt painted Six in one of the greatest of all his portraits. Six abstractedly pulls on a glove as he gazes at the spectator. He seems to pause, meditatively, before assuming his

public face and going out into the city streets. His casually draped red cape is beautifully set off by the sober grey tunic with its gold buttons. The open, confident brush-strokes emphasize the spontaneity of the image.

Rembrandt's most talented pupil was Carel Fabritius, one of the most exciting and elusive figures in seventeenth-century Dutch painting. He was a pupil in Rembrandt's studio in the early 1640s. In the four short years between his arrival in Delft in 1650 and his death in the explosion of the municipal powder dump, 'The Phoenix' (as he was called by Dirck van Bleyswijck in his 1667 history of Delft) created an original style which provides a link between Rembrandt and the Delft school of genre painting. The latter included Pieter de Hooch, Emanuel de Witte and the greatest of all Dutch genre painters, Johannes Vermeer. In Fabritius's very fine *Self-Portrait* (Plate 20) his fierce originality is evident. The stern, intense gaze, the tangled hair and the casual open-necked shirt all suggest self-conscious romantic genius.

Rembrandt's so-called *'Polish Rider'* (Plate 26) which dates from about 1655, is also an unconventional and enigmatic portrait. The horse is gaunt, almost skeletal, rendered in broad, grey brush-strokes against a forbidding landscape which is modelled exclusively in brown tones. The picture's title was suggested not only by its presence in Poland in the eighteenth century, but also by the figure's dress and weaponry. The rider's determined expression and martial appearance have provoked a rash of interpretations: is he a legendary Polish hero, the Christian Knight ever watchful against the infidel, or perhaps the Prodigal Son? The truth may be more straightforward: could this not simply be a romantic portrait of one of the many Eastern European noblemen who came to Holland to study at Dutch universities? While speculation continues, the picture still withholds its secret. It remains one of Rembrandt's most fascinating masterpieces.

The group portrait is a particularly Dutch subject, and portraits of the civic guard and of guild members provided lucrative commissions for many Dutch painters. Frans Hals was for many years the favoured artist of successive generations of the Haarlem civic guard, and he brought a wealth of experience of group portraiture to his two late masterpieces, the *Regentesses* and the *Regents of the Old Men's Alms House* (Plate 40), in his native town. These two great canvases, painted in about 1664, face one another today in a room in the museum named after him in Haarlem. Although he did not intend any of the personal or social satire that later critics have read into the portraits, these paintings are remarkably candid. Admittedly, Hals was destitute in the last years of his life, and from 1662 until his death in 1666 received a small pension from the town of Haarlem, but he did *not* live in the Old Men's Alms House. The sitters, however, must have known what to expect from the artist who had been portraying their fellow townsmen for many years. In these group portraits all inessentials are ignored as the artist, now in his eighties, concentrates the spectator's eye on the faces and, to a lesser extent, the hands of his sitters. His brush moves in short, broken strokes, stabbing the canvas with a palette restricted to ochre, red, black and white.

Like Hals, Rembrandt painted group portraits, the most famous of which, the so-called *'Night Watch'*, dates from 1642. Among the outstanding portraits in Rembrandt's late style are *'The Jewish Bride'* (Fig. 31), and the unidentified *Family Group* at Brunswick (Plate 41), painted in the mid-1660s. Here the mood is tender, and the subtle unity of the composition is created by the mother's glance towards her eldest daughter. The father, his hand resting on his daughter's shoul-

Fig. 3
HERCULES
SEGERS
River Valley with
a Waterfall
c.1615–25. Etching.
London, British Museum

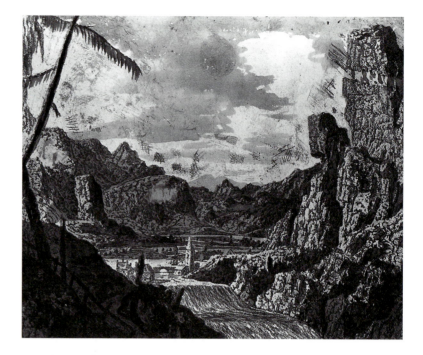

der, and yet slightly removed from the group, is a stable, authoritative presence.

It was not only portraiture that flourished in Holland in the seventeenth century. Among the other secular categories of painting in constant demand were the 'landskips and drolleries' seen by Evelyn at Rotterdam.

The immediate predecessors of the great age of Dutch landscape painting gathered in Amsterdam at the turn of the century. They included the Flemings David Vinckboons, Roelandt Savery (between periods working for Rudolf II in Prague) and Gillis van Coninxloo, as well as the native Amsterdammer Pieter Lastman, Rembrandt's master. Hendrick Goltzius in Haarlem and Jacob de Gheyn in The Hague were pursuing similar aims. Coninxloo, who had arrived in Amsterdam in 1595, was the progenitor of the great art of Hercules Segers. Born in Haarlem, Segers was probably still in Coninxloo's studio at the time of his master's death in 1607.

Segers was a truly innovative graphic artist: his landscape etchings, many of which are coloured, are among the finest productions of the century (Fig. 3). In his paintings, of which only fifteen or so survive, he expresses a vision that is both strange and evocative (Plate 2). The extensive flat landscape of Holland is modelled in subtle, striated tones of brown, green and grey. The rocky outcrops and tall firs of the Flemish landscapists have been abandoned, though Segers's haunting views can hardly be considered strictly naturalistic. Segers was a great inspiration to Rembrandt, who owned a number of his etchings and whose style, in his rare landscape paintings, is dependent upon him. Rembrandt's pupil, Philips Koninck, was also strongly influenced by Segers in his panoramas over the apparently endless Dutch countryside (Plate 30), though his richer palette and the grandeur of his cloud-filled skies are marks of his own imaginative achievement.

With Segers in the Haarlem guild were two other great innovators, Willem Buytewech, *Geestige Willem* or 'witty Willem', the pioneer of elegant figure groups, and the landscapist Esaias van de Velde. Born in Amsterdam, the son of a painter and a cousin of the engraver Jan van de Velde, Esaias was probably a pupil with Segers in the studio of Coninxloo. He went to Haarlem, no doubt attracted by the reputation of Goltzius's landscape drawings and hopeful of emulating his style.

He remained there until 1618, when he moved to The Hague, where he died in 1630. He is an important figure in the development of realistic landscape: he felt particularly free to experiment in his winter landscapes, such as that of 1623 (Plate 6), a subject scene that was comparatively new. Esaias's greatest pupil was Jan van Goyen, who was in his Haarlem studio in 1616 or thereabouts: he is represented in this selection by a small seascape, monumental in its composition, painted in the year of his death, 1656 (Plate 7).

Less realistic than the work of Esaias, yet crammed with animated detail, is that of his contemporary, Hendrick Avercamp, known as *de stom van Kampen* because he was dumb. A mute observer, he presents without comment a winter afternoon (Plate 3), with all the towns-people, the grand and the not so grand, out on the ice beneath a breathtakingly beautiful pink sky.

Haarlem was the home town of the greatest of all Dutch landscape painters, Jacob van Ruisdael, who entered the guild in 1648. Ruisdael was the heir to the developing tradition of realistic landscape and brought it to its finest expression. Soon after his entry into the guild, he went in 1650 on a trip with Nicolaes Berchem, whom Houbraken, the eighteenth-century historian of Dutch painting, says was his great friend. They travelled across Holland to the German border and beyond, particularly to the site of the castle of Bentheim. Ruisdael sketched the scene and returned to the subject in a number of paintings (Plate 12). His imagination was stirred by the drama of the site, the medieval granite castle perched high above sheer cliffs, the whole set amid rich, green vegetation. Less innately dramatic is the imag-

Fig. 4
MEINDERT HOBBEMA
The Avenue at Middelharnis
1689. Oil on canvas, 103.5 x 141 cm. London, National Gallery

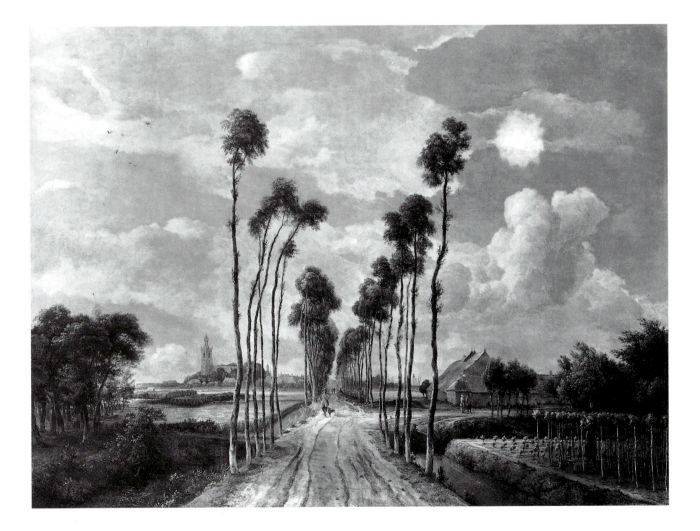

Fig. 5
JAN BOTH and
CORNELIS VAN
POELENBURGH
A Landscape with the
Judgement of Paris
Oil on canvas,
97 x 129 cm.
London,
National Gallery

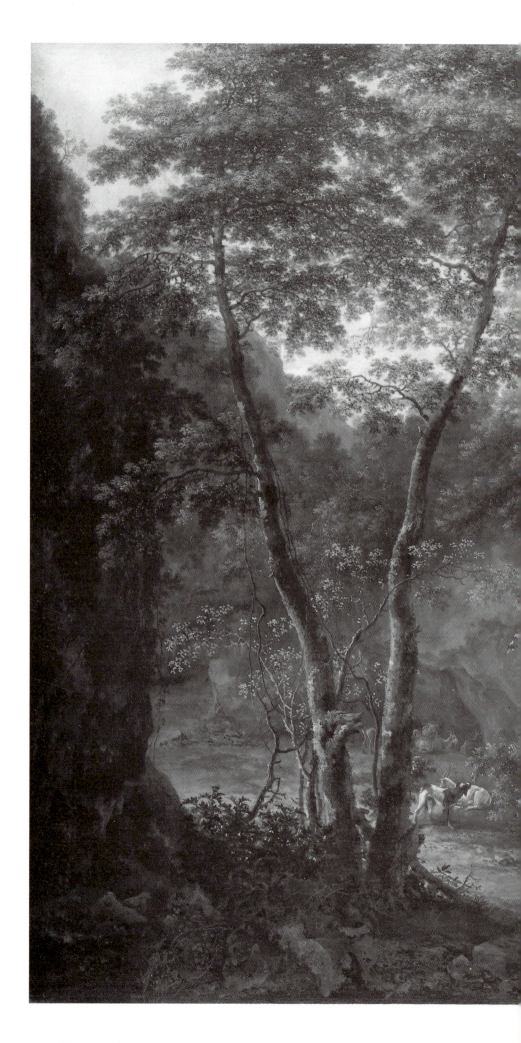

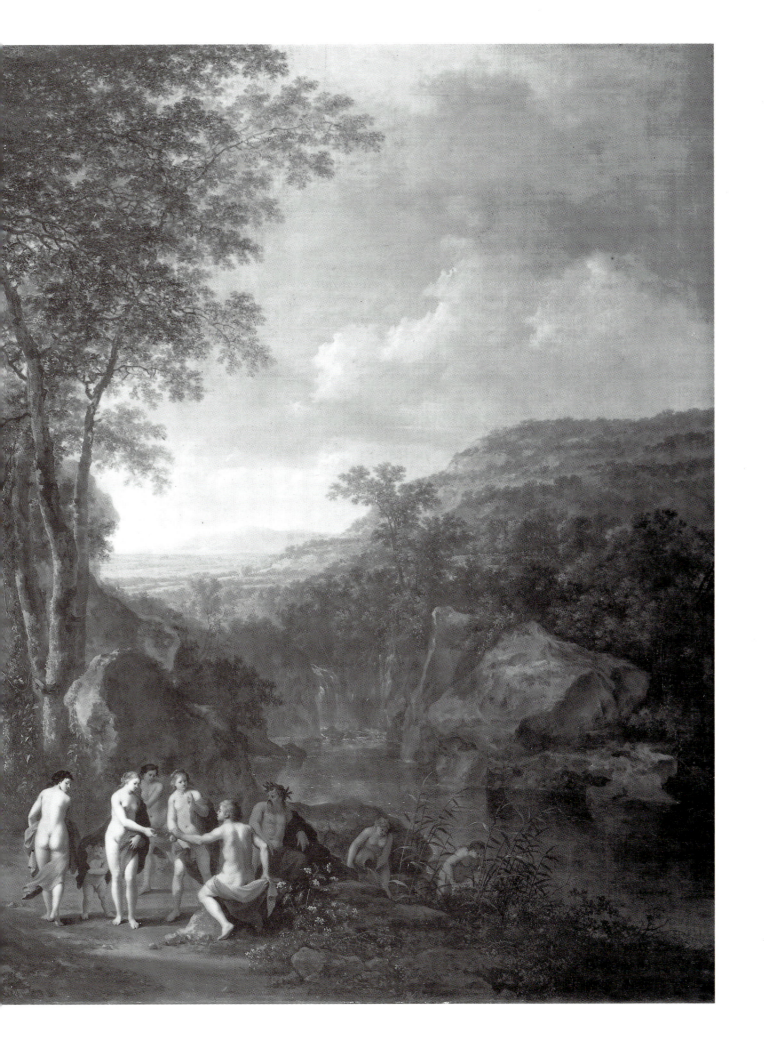

ined view (Plate 31) he painted in the late 1660s, after his move to Amsterdam in 1657. Here the Dutch countryside provides a foil to the clouds grimly lowering above, and throwing strong dark shadows across it. Constable was a great admirer of Ruisdael and profoundly influenced by him. In his third lecture to the Royal Academy, he said: 'Ruisdael delighted in, and has made delightful to our eyes, those solemn days, peculiar to his country and to ours, when without storm, large rolling clouds scarcely permit a ray of sunlight to break the shades of the forest. By these effects he enveloped the most ordinary scenes in grandeur ... '

Ruisdael's most talented pupil during his Amsterdam years was Meindert Hobbema, a native of Amsterdam, whose *Avenue at Middelharnis* in the National Gallery in London is one of the best known of all Dutch landscapes (Fig. 4). Hobbema lacked his master's sense of the dramatic, yet his quiet wooded landscapes, such as the *Road on a Dyke* (Plate 45), painted in 1663, are evoked with an exquisite sureness of tone.

Jacob van Ruisdael's travelling companion, Nicolaes Berchem, represents a different strain in Dutch landscape painting. He was one of the so-called Italianizing landscapists, some of whom had been to Italy, and all of whom interpreted the Dutch countryside in terms of Claude's Roman Campagna. Berchem went to Italy in 1642 with his cousin, Jan Baptist Weenix, who painted imaginary Italian seaports and still lifes with dead game, and who invariably signed his pictures 'Giovanni Battista Weenix' after his return. The landscape studies made by Berchem during his four-year stay in Rome served as material for paintings throughout his career. He was extraordinarily prolific and an influential teacher. His sketchy, highly coloured style (Plate 46) seems almost to foreshadow the Rococo and was much appreciated in eighteenth-century France when, for example, Boucher, who owned several pictures by Berchem, was influenced by him.

Berchem worked in Haarlem and after 1677 in Amsterdam, but the principal centre for Italianizing landscape painting was Utrecht. Its most important figure was Jan Both, who lived in Rome in the second half of the 1630s, and in whose work the Dutch woods are flooded with golden Italian light and peopled by Arcadian shepherds and Greek gods (Fig. 5). Aelbert Cuyp, who worked in his home town of Dordrecht, never visited Italy, but his study of Both's Italianate views caused him to abandon his early van Goyenesque style. His mature style (Plate 44) is characterized by the fall of rich sunlight, and the solidity and simplicity of his forms.

The Dutch appreciation of pictures which, in differing degrees, represented the physical world extended beyond landscape as such. The taste for marine seascapes was widespread, and they were collected both by merchants, such as Pieter van den Broecke, and cultivated humanists, like Constantijn Huygens. Jan Porcellis, a picture in whose style hangs at the back of Huygens's study in de Keyser's portrait (Plate 4), entered into a contract with the Antwerp cooper, Adriaen Delen, in 1615. Porcellis agreed to paint seascapes on forty boards supplied to him by Delen. The cooper was to supply him with the paints, give him an advance of thirty guilders and pay him fifteen guilders a week while he was working on the pictures. Porcellis would paint two seascapes a week which Delen would sell, the profits to be split two ways after Delen had subtracted forty guilders for paints and 160 for other materials and frames. The whole work was to take twenty weeks, during which time Delen was to arrange for Porcellis to have a pupil to assist him. This kind of contract, into which many Dutch artists entered in order to secure a regular income, was not of a

kind to encourage experimentation and imaginative flights.

Marine subjects were also painted by many landscape painters, such as Jan van Goyen (Plate 7) and Aelbert Cuyp, who depicted the mouth of the River Maas (Meuse) at Dordrecht (Plate 34). Jan van de Cappelle, on the other hand, devoted his attention almost exclusively to marine subjects. In his classically balanced compositions (Plate 35), he brings a dignity and sense of seriousness to his subjects, which suggest comparison with Ruisdael's landscapes. An Amsterdammer, van de Cappelle's style is based on that of Simon de Vlieger, who came to the city from Rotterdam.

Willem van de Velde the Younger was also a pupil of Simon de Vlieger, after having trained with his father, Willem the Elder. His brother Adriaen was an Italianizing landscape painter. Both Willems, father and son, painted seascapes exclusively, but Willem the Younger concentrated more and more on 'portraits' of individual ships and on naval engagements. After the social and economic disruption brought about by Louis XIV's invasion of Holland in 1672, the elder van de Velde decided to try and make his living in England, or, if that failed, in Italy. He and his son came to London late in that year, and soon afterwards the two painters were taken into the service of the king, Charles II. Sadly, the move to England had a deleterious effect on the young van de Velde's production, which became dependent on stale mannerisms. Rarely did he reproduce for his royal patron the quality seen in his early work from the Amsterdam years, as, for example, in *The Cannon Shot* (Plate 28).

Dutch painters also turned their attention to the beauty of their towns. The first artist to specialize in town views was Jan van der Heyden, who lived in Amsterdam. 'He painted', wrote Houbraken, 'every brick in his buildings ... so precisely that one could clearly see the mortar in the joints, and yet his work did not lose in charm or appear hard if one viewed the pictures as a whole from a certain distance.' This painstaking technique, perhaps developed during his apprenticeship to a glass painter, can be seen in his view of the small town of Veere in Zeeland (Plate 10).

The Haarlem painter Pieter Saenredam brought a cooler and more dispassionate eye to his accounts of Dutch buildings. Trained in the studio of the Caravaggesque painter Frans de Grebber, he entered the Haarlem guild in 1623 and, according to his first biographer Cornelis de Bie, from 'about 1628 devoted himself entirely to painting perspectives, churches, halls, galleries, buildings and other things from the outside as well as the inside, in such a way, after life, that their essence and nature could not be shown to greater perfection ...'. Saenredam's view of *St Mary's Square and St Mary's Church at Utrecht* (Plate 11) was painted in 1662, three years before his death. The elaborate preliminary drawing, executed with the aid of measurements and plans, is dated 1636. Despite this gap of a quarter of a century, Saenredam made few changes when he came to paint the scene: figures were moved, two trees and a small building omitted, and the tower heightened. Saenredam's exacting method might suggest the dullness of architectural draughtsmanship. However, when he came to transfer his drawings to panel, his exquisite palette and his feeling for texture produced a series of delicate, understated masterpieces.

Saenredam painted many church interiors, in particular a number of St Bavo at Haarlem, where he is buried. This church was also a favourite of the younger Emanuel de Witte, who came from Alkmaar to work in Delft and later in Amsterdam. During his years in Delft de Witte would have become familiar with the work of Carel Fabritius, which influenced his own style. From 1650, de Witte, who had previ-

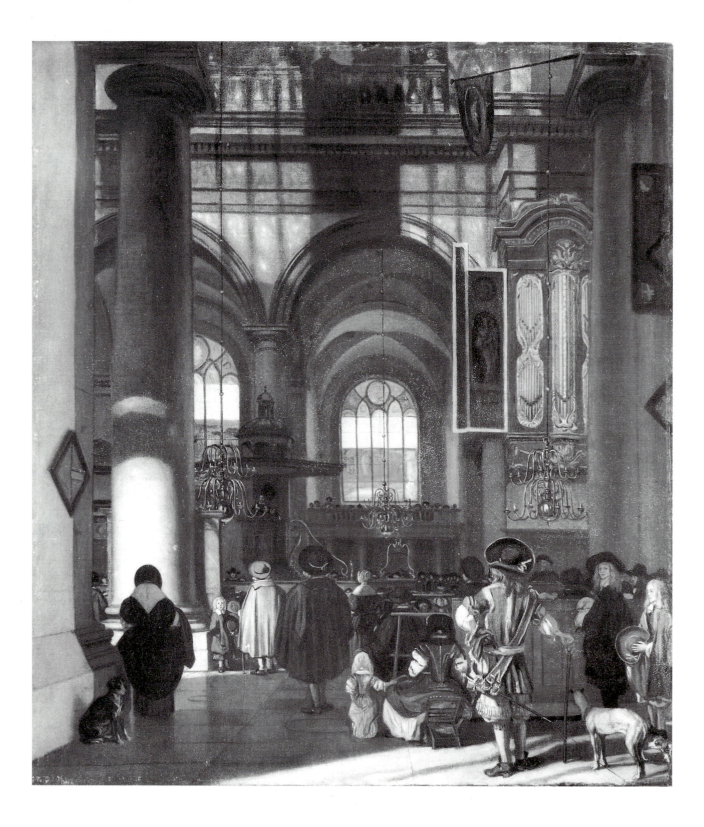

ously painted a number of subject pictures and portraits, concentrated on church interiors (Fig. 6). Houbraken informs us that he was 'famed for his knowledge of perspective', but architectural accuracy was not his first concern. The figures placed in the foreground of his *Interior of a Protestant Gothic Church* of 1668 (Plate 38) idly stroll and talk, breaking up the severity of the composition. The gravedigger's tools, the brass candelabra, the organ case and the armorials are clearly described, while the whitewashed walls and pillars are enlivened by the strong fall of sunlight. De Witte's colours are far warmer and richer than Saenredam's, and his technique closer to genre painting than to architectural draughtsmanship.

Just as sixteenth-century Flemish landscape painting was the forcing-ground for Dutch landscape of the seventeenth century, and Flemish perspective studies the parent of Dutch townscape, so the flower paintings of Jan Brueghel and his contemporaries, larded with symbol and allegory, were the predecessors of Dutch realistic still-life painting. Some contain symbolic elements, but Willem Kalf's *pronkstilleven* (*pronk* means ostentatious display) had the purpose merely of recording, in elegant groupings, rare and beautiful objects which were treasured by the wealthy merchant class of Amsterdam (Fig. 7). After settling in the city in 1653, Kalf catered to this taste in a series of remarkable paintings, which seem to apply Vermeer's palette and technique to still-life subjects. In *Still Life with Nautilus Cup* (Plate 29), the china bowl, nautilus cup, peeled lemon and rich carpet are all meltingly painted with highlights of pure pigment. Goethe wrote of a still life by Kalf that the picture showed 'in what sense art is superior to nature and what the spirit of man imparts to objects when it views them with creative eyes. There is no question, at least there is none for me, if I had to choose between the golden vessels and the picture, that I would choose the picture.'

The pictures that Evelyn calls 'drolleries', dismissing them as 'clownish representations', are pictures that we should describe with the French word 'genre'. The word is used today to cover a wide range of figure paintings, often on a small scale, depicting scenes from everyday life. The origin of this use of the word is obscure and was certainly not employed by the seventeenth-century Dutch, who had their own words to describe different types of genre scenes. Evelyn's 'drolleries', we may imagine, resembled Adriaen van Ostade's peasant interiors rather than Vermeer's elegant rooms. In discussing these pictures, one note of caution is necessary: many of the subjects which we think of as showing scenes from everyday life may well have possessed emblematic, or moralistic, significance for their seventeenth-century audience. For example, the subject of ter Borch's *A Boy Ridding his Dog of Fleas* (Plate 33) was often used in series of 'The Five Senses' to signify touch. Similarly, Frans van Mieris's *A Lady Looking into a Mirror* (Plate 48) belongs to a tradition of representations of *superbia*, the sin of pride. However, as with still lifes, many of these connotations may have dropped away even during the seventeenth century as the subject came to stand simply for itself.

The greatest of all Dutch genre painters, Johannes Vermeer, began his career as a painter of large-scale figure scenes which suggest familiarity with the work of the Utrecht followers of Caravaggio. Relatively little is known of Vermeer's life and the chronology of his small *oeuvre* is confused. He was born in Delft in 1632 and entered the guild in 1653, the year of his marriage to the daughter of a Roman Catholic family. He may have become a Roman Catholic himself at this time. Vermeer was elected to hold office in the guild on four occasions, which suggests that he was regarded with respect by his fellow guilds-

Fig. 6
EMANUEL
DE WITTE
Church Interior
1674. Oil on canvas,
79 x 69 cm. Cologne,
Wallraf-Richartz Museum

men. As is the case with many Dutch artists, we cannot be sure to what extent he was dependent on the sale of his paintings for his living: he was also active as an art dealer and, after his father's death, ran the family inn. He was continually in financial difficulties and a few months after his death in 1675 his widow applied for a writ of insolvency. She claimed that the French invasion had brought about a decline in the demand for pictures. Foreign collectors passing through Delft are known to have visited Vermeer's studio: for example, the Frenchman Balthasar de Monconys, in 1663, who thought his work overpriced. His paintings seem to have fetched reasonably high prices (one was bought for 600 guilders), but they were far below the sums paid to the fashionable artists in Amsterdam.

The Procuress of 1656, now in Dresden, is Vermeer's earliest dated painting. In the picture of *A Girl Reading at an Open Window* (Plate 18), in the same gallery, probably painted about two years later, the artist has simplified his subject-matter. He concentrates on the solitary, self-absorbed figure who reads a letter, no doubt from an absent lover. The artist seems to enjoy his own virtuosity: the girl's reflection in the window, the foreground still-life, the illusionistic curtain which cuts off the right-hand side of the room, all are rendered with self-conscious skill. The paint is thickly applied, the brush loaded with pure pigment to touch in the highlights on the fruit, the curtain and the girl's braided hair. It is not known who was Vermeer's master (although a likely candidate is the history painter, Leonart Bramer) but his early style suggests knowledge of the work of Rembrandt's talented pupil, Carel Fabritius, who lived and worked in Delft; at the time of his death, Vermeer owned three pictures by Fabritius.

The subject of a scholar at work, as in Vermeer's *The Geographer* (Plate 42), is a familiar one for Dutch artists: Rembrandt treated it a number of times, notably in an etching of the early 1650s known as *Dr Faustus*. Rembrandt's interpretation is mystical and dramatic, with suggestions of alchemy, dark arts and cabbalistic symbols: Vermeer's is rational and contemporary. It shows a seventeenth-century scientist, his head raised from his maps for a moment, dividers in hand. It reminds us of the scientific temper of the age, of the great advances made in the description of the physical world. (Anthony van Leeuwenhoeck, the great Dutch biologist who had a chair at the university of Leiden, was appointed executor of Vermeer's bankrupt estate, and may have been an acquaintance of the artist.)

In *The Music Lesson* (Fig. 8), probably painted at about the same time as *The Geographer*, the self-conscious virtuosity is still evident in the use of steep perspective. Vermeer has placed the figures at the far end of the room, and draws our attention to the mullioned windows, the fall of light on the tiled floor, the white Delftware jug, the table, chair and cello, before our eye eventually reaches the couple engaged in one of those speechless musical courtships so favoured by Dutch genre painters. Here the colours are rich, far warmer than the almost pastel tones of the works of the mid-1660s, like the Mauritshuis *Head of a Girl*, and the paint applied more thinly and evenly than in the Dresden *Girl at a Window*. In *A Painter in his Studio* (Plate 43) the palette is again rich and the paint applied to almost porcelain smoothness.

Pieter de Hooch was an exact contemporary of Vermeer, born only three years earlier, in 1629; he entered the Delft guild two years after Vermeer in 1655. No direct relationship between the two artists has been traced, but it would seem that de Hooch's contact with the vigorous art of Carel Fabritius and other Delft artists caused him to abandon the barrack room scenes, in the manner of the Amsterdam

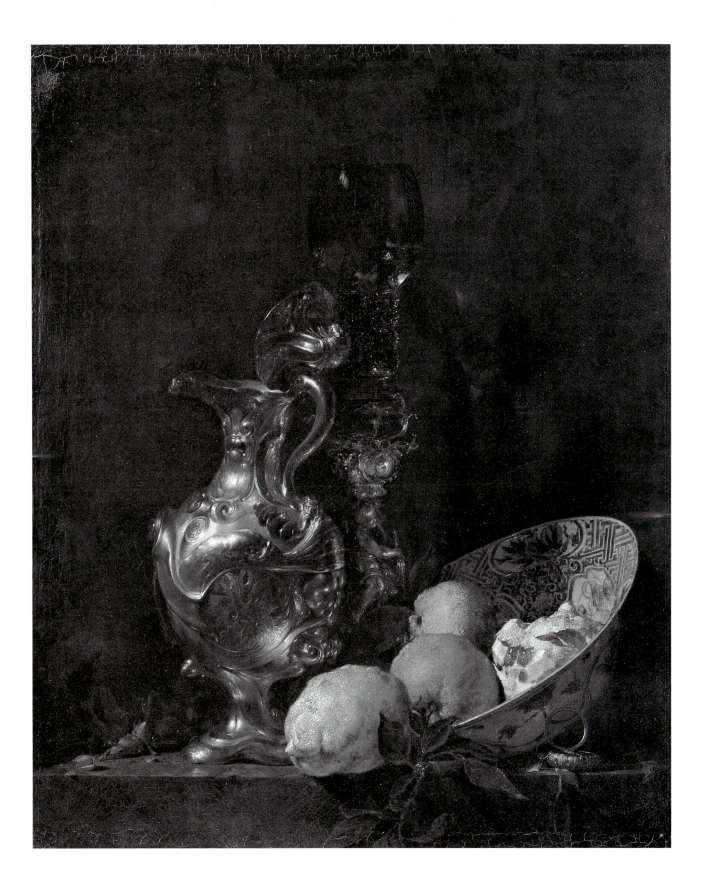

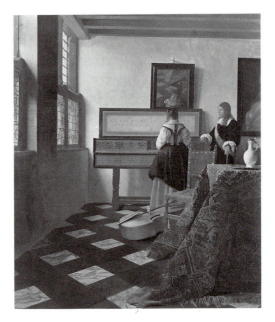

Fig. 8
JOHANNES
VERMEER
The Music Lesson
c.1662. Oil on canvas,
73.6 x 64.1 cm. London,
Buckingham Palace
(reproduced by gracious
permission of Her Majesty
the Queen)

Fig. 9
GERARD
TER BORCH
A Lady Reading
a Letter
1660–2. Oil on canvas,
44.4 x 32.8 cm. London,
Wallace Collection

painters Codde and Duyster, of his early period. Instead he took for his subjects scenes from the comfortable daily life of the Delft middle classes. *The Courtyard of a House in Delft* (Plate 19), dated 1658, is one of this series of domestic *vignettes*, which he painted during the 1650s, before his move to Amsterdam. It employs his characteristic device of a view opened up within the picture. Here we look through an archway and a passage, past the standing woman, to a distant canal flooded with sunlight. Balancing this light-filled vista is the dark background behind the figure of a maid at whom the child trustingly glances. The perspective of the brick courtyard and the still-life of the brush and bucket add to the visual complexity of the composition.

In the early 1660s de Hooch moved from Delft to Amsterdam. His earliest pictures after the move still possess the harmonious colouring and strength of composition of his Delft paintings. In *At the Linen Closet* (Plate 39) of 1663, a housewife's domestic routine is the uneventful subject: again the artist has included a deep vista, this time through the front of the house onto the canal and the houses opposite. Later in the 1660s de Hooch's patrons were grander, and a loss of simplicity in his interiors coincided with a marked falling-off in the quality of the pictures themselves. The interiors of the late 1660s onwards suffer from acid colours and clumsy figure-drawing. It is the series of carefully composed and subtly coloured masterpieces from his Delft years that entitles de Hooch to his place among the greatest of Dutch genre painters.

Thoré-Bürger, the nineteenth-century French critic, placed Gerard ter Borch second only to Rembrandt in the pantheon of seventeenth-century Dutch artists, and certainly his delicate portraits and domestic interiors combine psychological nuance with a quite extraordinary technical virtuosity in the treatment of texture, whether of hair, skin, fur or satin (Fig. 9). Ter Borch travelled extensively in Europe, visiting England, France, Spain and Italy, and in 1648 was in Münster to record the signing of the peace treaty with Spain. For his small painting of the swearing of the oath of ratification, now in the National Gallery, London, he asked 6,000 guilders, four times the sum Rembrandt received for *The Night Watch*. In 1654 ter Borch married and settled in the provincial northern town of Deventer, and from these later years (he died there in 1681) date the interior scenes which mark the highest point of his achievement. *A Boy Ridding his Dog of Fleas* (Plate 33) was painted soon after ter Borch's arrival in Deventer, in about 1655, and his treatment of this mundane subject in muted tones is characteristic of his understated art. The boy's discarded homework is a charmingly observed human detail.

Ter Borch had few pupils, but one, Caspar Netscher, profited well from his apprenticeship at Deventer. He successfully adopted his master's technique in the painting of varying textures, and in *The Lace-Maker* (Plate 32) of 1662 achieves a subtle and original design. The engraving tacked to the bare wall suggests that an interest in the visual arts existed even at this level of society. Netscher moved to The Hague in 1662, and devoted his talents to portraits of members of the court circle.

Gabriel Metsu was a pupil of Gerrit Dou (who himself had been Rembrandt's first pupil) in Leiden but, like Pieter de Hooch, he gravitated to Amsterdam, where he had settled by 1657. His pictures have a richness of surface which contrast with his master's highly wrought miniaturist panels, and he is the most underrated of the Dutch genre painters. His colours are rich and his harmonies resonant. In *The Sick Child* (Plate 15), painted in about 1660, the figures, surely based on a Virgin and Child composition, are brilliantly characterized, the child

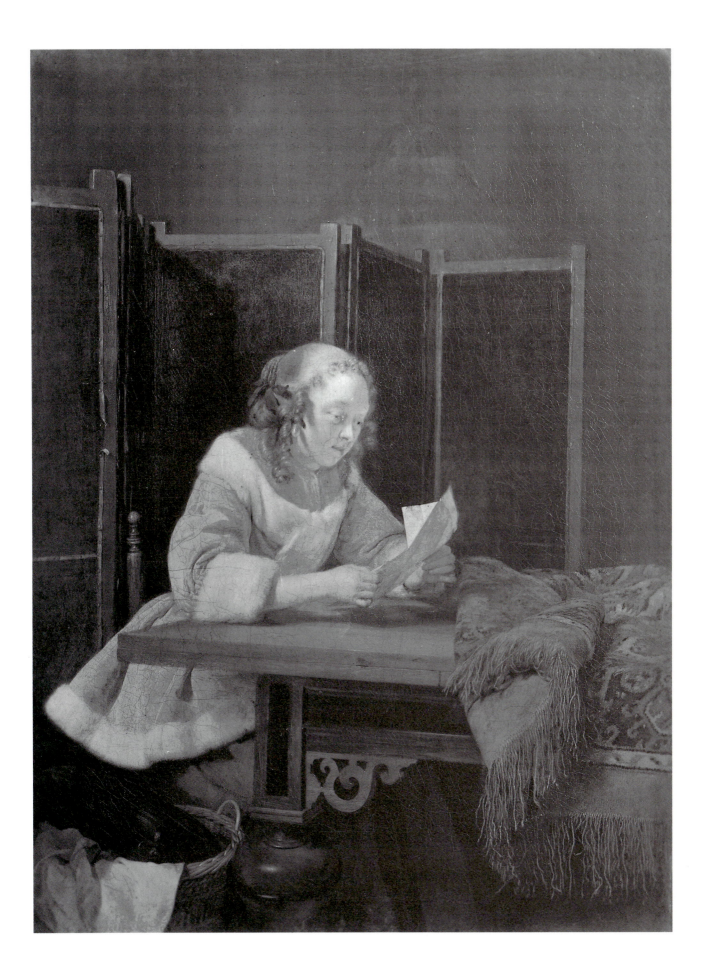

perhaps petulant rather than sick. The group may recall Vermeer, yet the colours are far richer, the shadows stronger and the brushwork more open.

Another pupil of Gerrit Dou was Frans van Mieris the Elder, who was the heir to the tradition of *fijnschilderij* or 'fine painting' in Leiden, remaining there throughout his working life. Like Dou, his work was popular and expensive. He interpreted and adapted many of Dou's designs, but in a picture such as *A Lady Looking into a Mirror* (Plate 48), he is wholly original, rivalling even ter Borch in his treatment of rich materials. The image no doubt belongs to the late medieval tradition of representations of *superbia* (Pride), but we may suppose that the artist intended us to admire rather than condemn.

Jan Steen is irrepressible and unpredictable in his art, as he was in his life. His *oeuvre* is huge and varied, ranging from small delicate landscapes like the *Skittle Players outside an Inn* (Plate 22) to large figure compositions like *The Village School* (Plate 17). His pictures also vary enormously in quality, suggesting that he was not above hackwork in order to supplement his income. Born in Leiden in 1626, Steen entered the university but was soon on the move, working in the studios of Nicolaes Knüpfer at Utrecht, Adriaen van Ostade at Haarlem and Jan van Goyen, whose daughter he married. He continued his peripatetic existence, combining the profession of painter with that of tavern-keeper, until he finally settled in his home town in 1670, where he died nine years later.

The Village School (Plate 17) reveals Steen's debt to Adriaen van Ostade's peasant interiors. The rowdy class-room, presided over by the kindly schoolmistress and the absurd schoolmaster, and the children represented in every attitude from the studious to the violent, show his imagination at its richest. By contrast, the *Skittle Players outside an Inn* (Plate 22), painted in the early 1660s, recalls the pleasure of a summer afternoon. It is a small, glittering panel, painted in sharp blues and greens, with mottled sunlight filtering through the trees.

One group of pictures represented in the present selection remains to be mentioned – paintings of religious subjects. As we can plainly see in the paintings of church interiors by Saenredam and de Witte, the traditional source of patronage for religious paintings – the church itself – had almost completely disappeared with the whitewashing of church walls by the Calvinists. Despite Erasmus's vacillations, many Netherlanders were early and enthusiastic converts to Protestantism. The long war with Roman Catholic Spain encouraged identification of the cause of freedom with Protestantism, and more particularly with Calvinism, the extreme form of Protestantism formulated by John Calvin in Geneva. Calvin's reading of the Old Testament led him to condemn any form of religious imagery, including painting, as Popish idolatry, and his teaching provided the pretext for the great iconoclasm which swept the Netherlands in 1566, and for further outbreaks in later years.

However, the triumph of Calvinism was not absolute, and several artists were commissioned to paint large-scale religious works, particularly the group of followers of Caravaggio working at Utrecht in the early part of the century. Prominent among this group were Gerrit van Honthorst and Hendrick ter Brugghen. Honthorst spent ten years in Italy where he was known as *Gherardo della notte*. His fellow Utrecht Caravaggist, Hendrick ter Brugghen, was a far more sensitive and original painter, interpreting the style of Caravaggio and his Italian followers in a refined and personal idiom. By 1615 he had returned from Rome, where he had lived for a decade, and worked in his native Utrecht until his death in 1629. *The Flute Player* (Plate 1), one of a pair

now at Kassel, displays virtuoso treatment of the drapery in the sleeve of the boy, who wears the jacket of an Italian *bravo*. Caravaggio's use of individual models in religious paintings, and his dramatic *chiaroscuro*, were adopted and developed by these Utrecht artists. Rembrandt looked carefully at their work, particularly in the 1630s when in pictures like the Frankfurt *Blinding of Samson* and the London *Belshazzar's Feast* he was experimenting with large-scale religious painting. However, as the demand for this kind of full-blooded Baroque *tour de force* declined, Rembrandt evolved a new kind of religious painting, in small pictures which express his deeply-felt response to Biblical events. A beautiful early example is the *Jeremiah Lamenting the Destruction of Jerusalem* (Plate 5), painted in 1630. The picture belongs to a group of studies of elderly people from his early years: the burning city and the soldiers in the gateway are little more than a backdrop to the figure of the sorrowing old man, who rests his elbow on his own book of prophecies (the inscription 'Bibel' was added by a later painter). It is a moving image of the inevitability of human folly, painted in strong contrasts of light and dark, and in a painstakingly detailed technique which recalls the artist's debt to his master, Pieter Lastman.

In *Christ and the Woman Taken in Adultery* (Plate 13) of 1644, the figures are dwarfed by the massive temple, their drama heightened by a fall of light which suffuses the rich colour of the altar and the robes of the priests. The panel is in some senses a transitional one, the general composition and the splendour of the temple, so enthusiastically detailed by the painter, contrasting with the simplicity of the foreground scene, which is treated in the broader style of his later work.

Rembrandt's return to a large format for religious paintings a decade later no doubt reflects the liberalization of the religious situation in Holland. Although not meant for churches, these works suggest that patrons now felt that to possess a large religious picture would not anger their Calvinist neighbours. One of Rembrandt's greatest religious works is the *Jacob Blessing the Children of Joseph* (Plate 27), painted in 1656 during one of the most fiercely creative periods of his career. Joseph tries to guide his father's hand to the head of the first-born, but Jacob's right hand rests on the blond head of the younger child, Ephraim, to whom the Gentiles trace their ancestry. The elder boy, Manasseh, who is small and dark, is blessed with the left hand. The submissive gesture of Ephraim's crossed hands, Joseph's tender regard for his father, Manasseh's intense gaze towards his brother, all are painted in strong, broad strokes (Fig. 10). The unusual presence of Asenath, Joseph's wife, also in an attitude of submission, strengthens and balances the composition.

Dutch painting closely reflects Dutch society: not merely in temporary fashions but in more profound ways – for example, in the importance placed on the family and on groups such as the guilds and the civic guards; in the pride taken in the countryside and in the towns; and in the importance of the sea, on which the nation was dependent for its economic well-being. The Dutch of all social classes were eager to adorn their houses with pictures, or, as in the case of Netscher's *Lace-Maker*, with prints. The existence of numerous local schools, far from fashionable Amsterdam and the court-dominated Hague, attests the existence of a mass market for pictures. Paintings were cheap, and many artists had to combine their work with other employment, while others found themselves in dire financial straits. Rembrandt himself was declared bankrupt. Paintings must have been largely considered as domestic furniture, and painters consequently regarded as craftsmen, like carpenters and weavers.

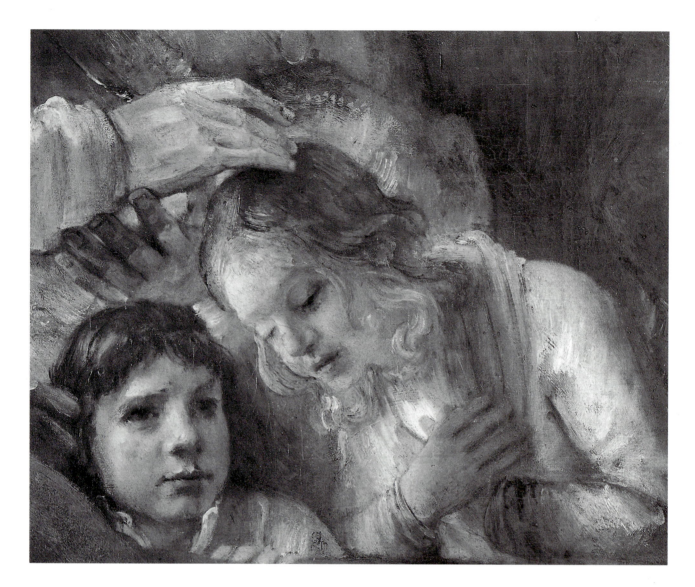

Fig. 10
REMBRANDT
VAN RIJN
Detail from 'Jacob
Blessing the Children
of Joseph'

Yet, despite the special features of the Dutch market for pictures and the low social status of the painter in Dutch society, we must not imagine that Dutch painting was entirely cut off from developments in the rest of Europe. This is a misconception that even the great Dutch historian, Johan Huizinga, expressed in his essay on Dutch seventeenth-century civilization, written in the patriotic days of the German occupation. Art has its own self-perpetuating history, regardless of the demands of patronage. Ruisdael's lowering skies and Vermeer's billowing curtains are as much a part of the European movement we call the Baroque as Rubens's altarpieces or Lanfranco's frescoes. The scale is different, but the 'domestic Baroque' of the Dutch painters reveals a similar delight in dynamic, swirling compositions and rich colour, and possesses an equal emotional intensity.

Select Bibliography

GENERAL WORKS

S. Alpers, *The Art of Describing, Dutch Art in the Seventeenth Century*, London, 1983

A.T. van Deursen, *Plain Lives in a Golden Age: Popular culture, religion and society in seventeenth-century Holland*, Cambridge, 1991

R.H. Fuchs, *Dutch Painting*, London, 1978

B. Haak, *The Golden Age, Dutch Painting of the Seventeenth Century*, London, 1984

J. Huizinga, *Dutch Civilisation in the Seventeenth Century*, London, 1968

J.M. Nash, *The Age of Rembrandt and Vermeer*, London, 1972

J.L. Price, *Culture and Society in the Dutch Republic during the Seventeenth Century*, London, 1974

J. Rosenberg, Seymour Slive, E.H. ter Kuile, *The Pelican History of Art: Dutch Art and Architecture 1600-1800*, Harmondsworth, 1972

S. Schama, *The Embarrassment of Riches: An Interpretation of Dutch Culture in the Golden Age*, London, 1987

W. Stechow, *Dutch Landscape Painting of the Seventeenth Century*, London, 1966

MONOGRAPHS

A. Blankert et al., *Vermeer*, New York, 1988

A. Bredius, *Rembrandt: The Complete Edition of the Paintings*, 3rd edition by H. Gerson, London, 1969

C. Brown, *Carel Fabritius*, Oxford, 1981

J. Bruyn et al., *A Corpus of Rembrandt Paintings*, 3 vols., The Hague, 1982 –

B.D. Kirschenbaum, *The Religious and Historical Paintings of Jan Steen*, Oxford, 1977

O. Naumann, *Frans van Mieris*, 2 vols., Doornspijk, 1981

F. Robinson, *Gabriel Metsu*, New York, 1974

G. Schwartz, *Rembrandt, his life, his paintings*, London, 1985

G. Schwartz and M.J. Bok, *Pieter Saenredam*, London, 1990

S. Slive, *Frans Hals*, 3 vols., London, 1970–4

P. Sutton, *Pieter de Hooch*, Oxford, 1980

A. Wheelock, *Vermeer*, New York, 1981

C. White, *Rembrandt*, London, 1984

EXHIBITION CATALOGUES

Jacob van Ruisdael, catalogue by S. Slive, Mauritshuis, The Hague; Fogg Art Museum, Cambridge, Mass., 1981

Masters of Dutch Genre Painting, catalogue by P. Sutton et al., Philadelphia Museum of Art; Gemäldegalerie, Berlin-Dahlem; Royal Academy of Arts, London, 1984

Dutch Landscape: The Early Years, catalogue by C. Brown et al, National Gallery, London, 1986

Masters of Dutch Landscape, catalogue edited by P. Sutton, Rijksmuseum, Amsterdam; Museum of Fine Arts, Boston; Philadelphia Museum of Art, 1987–8

Frans Hals, catalogue by S. Slive, National Gallery of Art, Washington; Royal Academy of Arts, London; Frans Halsmuseum, Haarlem, 1989–90

Rembrandt: The Master and his Workshop, catalogue by C. Brown, J. Kelch, P. van Thiel et al, Altes Museum, Berlin; Rijksmuseum, Amsterdam; National Gallery, London, 1991–2

List of Illustrations

Colour Plates

1 Hendrick ter Brugghen
The Flute Player
1621. Oil on canvas, 70 x 55 cm. Kassel,
Gamäldegalerie

2 Hercules Segers
A River Valley with a Group of Houses
c.1625. Oil on canvas, 70 x 86.6 cm. Rotterdam,
Boymans-van Beuningen Museum

3 Hendrick Avercamp
A Scene on the Ice near a Town
c.1615. Oil on wood, 58 x 89.8 cm.
London, National Gallery

4 Thomas de Keyser
Constantijn Huygens and his Clerk
1627. Oil on wood, 92.4 x 69.3 cm.
London, National Gallery

5 Rembrandt van Rijn
Jeremiah Lamenting the Destruction
of Jerusalem
1630. Oil on panel, 58.3 x 46.6 cm.
Amsterdam, Rijksmuseum

6 Esaias van de Velde
A Winter Landscape
1623. Oil on panel, 25.9 x 30.4 cm.
London, National Gallery

7 Jan van Goyen
Haarlemer Meer
1656. Oil on canvas, 39 x 54 cm.
Frankfurt, Städelsches Kunstinstitut

8 Frans Hals
Pieter van den Broecke
c.1633. Oil on canvas, 71.2 x 61 cm.
London, Kenwood House, The Iveagh Bequest

9 Johannes Verspronck
Girl in a Blue Dress
1641. Oil on canvas, 82 x 66.5 cm.
Amsterdam, Rijksmuseum

10 Jan van der Heyden
Approach to the Town of Veere
c.1665. Oil on panel, 45.7 x 55.9 cm.
London, Buckingham Palace

11 Pieter Jansz. Saenredam
St Mary's Square and St Mary's Church
at Utrecht
1662. Oil on wood, 109.5 x 139.5 cm.
Rotterdam, Boymans-van Beuningen Museum

12 Jacob van Ruisdael
The Castle at Bentheim
1651. Oil on canvas, 97.7 x 81.3 cm.
Norfolk, Private Collection

13 Rembrandt van Rijn
Christ and the Woman Taken in Adultery
1644. Oil on panel, 83.8 x 65.4 cm.
London, National Gallery

14 Rembrandt van Rijn
Agatha Bas
1641. Oil on canvas, 104 x 82 cm.
London, Buckingham Palace

15 Gabriel Metsu
The Sick Child
c.1660. Oil on canvas, 33.2 x 27.2 cm.
Amsterdam, Rijksmuseum

16 Michiel Sweerts
The Drawing Class
c.1656-8. Oil on canvas, 76.5 x 110 cm.
Haarlem, Frans Halsmuseum

17 Jan Steen
The Village School
c.1670. Oil on canvas, 83.8 x 109.2 cm.
Edinburgh, National Gallery of Scotland

18 Johannes Vermeer
A Girl Reading at an Open Window
c.1657. Oil on canvas, 83 x 64.5 cm. Dresden,
Staatliche Kunstsammlungen, Gemäldegalerie

43 Johannes Vermeer
 A Painter in his Studio
 c.1666-7. Oil on canvas, 120 x 100 cm.
 Vienna, Kunsthistoriches Museum

44 Aelbert Cuyp
 River Landscape
 c.1655–60. Oil on canvas, 123 x 241 cm.
 London, National Gallery

45 Meindert Hobbema
 Road on a Dyke
 1663. Oil on canvas, 108 x 128.3 cm.
 Blessington, Ireland, Sir Alfred Beit, Bt.

46 Nicolaes Berchem
 Peasants with Cattle by a Ruined
 Aqueduct
 c.1658. Oil on wood, 47.1 x 38.7 cm.
 London, National Gallery

47 Jan van Huysum
 Hollyhocks and Other Flowers in a Vase
 c.1710. Oil on canvas, 62.1 x 52.3 cm.
 London, National Gallery

48 Frans van Mieris
 A Lady Looking in a Mirror
 c.1670. Oil on wood, 43 x 31.5 cm. Munich,
 Alte Pinakothek

Text Illustrations

Comparative Figures

11 Hendrick ter Brugghen
The Singing Lute-Player
1624. Oil on canvas, 100.5 x 78.7 cm. London,
National Gallery

12 Hendrick Avercamp
Golf on the Ice
Pen and brown ink, watercolours on white paper,
17.8 x 23.8 cm. Windsor, Royal Collection

13 Rembrandt van Rijn
Tobit and Anna
1626. Oil on wood, 39.5 x 30 cm. Amsterdam,
Rijksmuseum

14 Cornelis Vroom
A Landscape with a River by a Wood
1626. Oil on wood, 31.2 x 44.2 cm. London,
National Gallery

15 Jan van Goyen
Canal Landscape
Black chalk and wash. Paris, Musée du Louvre

16 Jan van der Heyden
View in Amsterdam
Oil on wood, 44 x 54.4 cm. Richmond, Virginia,
Virginia Museum of Fine Arts

17 Rembrandt van Rijn
The Presentation in the Temple
1631. Oil on panel, 61 x 48 cm. The Hague,
Mauritshuis

18 Rembrandt van Rijn
Portrait of Nicolaes van Bambeeck,
Husband of Agatha Bas
1641. Oil on canvas, 108.8 x 83.3 cm. Musée Royal
des Beaux-Arts, Brussels

19 Michiel Sweerts
In the Studio
1652. Oil on canvas, 73.5 x 58.8 cm. Detroit,
Detroit Institute of Arts

20 Pieter van der Heyden after Pieter Bruegel
The Ass at School
1557 (original drawing 1556). Print, 22.8 x 29.4 cm.
London, British Museum

21 Pieter de Hooch
The Pantry
Oil on canvas, 65 x 60.5 cm. Amsterdam,
Rijksmuseum

22 Carel Fabritius
The Raising of Lazarus
c.1643–6. Oil on canvas, 210.5 x 140 cm. Warsaw,
Museum Narodowe

23 Rembrandt van Rijn
Titus
c.1659. Oil on canvas, 67.5 x 55 cm. London,
Wallace Collection

24 Adriaen van Ostade
Interior of an Inn
c.1653. Pen and brown ink, grey wash and pencil
on white paper, 16.7 x 17.5 cm.
Windsor, Royal Collection

25 Frans Hals
Stephanus Geraerdts
c.1650-2. Oil on canvas, 115.4 x 87.5 cm. Musée
Royal des Beaux-Arts, Antwerp

26 Willem van de Velde the Elder
The Battle of Scheveningen,
10 August 1653
1653. Grisaille on wood, 113.3 x 155.8 cm.
Greenwich, National Maritime Museum

27 Rembrandt van Rijn
Cottages beside a Canal, with a Church
and Sailing Boat
c.1642-3. Etching, 14 x 20.7 cm.
London, British Museum

28 Caspar Netscher
A Lady Teaching a Child to Read
c.1675. Oil on wood, 45.1 x 37 cm.
London, National Gallery

29 Gerard ter Borch
An Officer Dictating a Letter
c.1655. Oil on canvas, 74.5 x 51 cm.
London, National Gallery

30 Frans Hals
 Regentesses of the Old Men's Alms
 House, Haarlem
 c.1663–5. Oil on canvas, 170.5 x 249.5 cm.
 Haarlem, Frans Halsmuseum

31 Rembrandt van Rijn
 The Jewish Bride
 c.1665. Oil on canvas, 121.5 x 166.5 cm.
 Rijksmuseum, Amsterdam

32 Johannes Vermeer
 The Astronomer
 1668. Oil on canvas, 50 x 45 cm.
 Paris, Private Collection

33 Joannes Vermeer
 Allegory of Faith
 1672–3. Oil on canvas, 113 x 88 cm.
 New York, Metropolitan Museum of Art

34 Nicolaes Berchem
 The Round Tower
 1656. Oil on canvas, 88.5 x 70 cm.
 Amsterdam, Rijksmuseum

35 Jan van Huysum
 Flowers in a Terracotta Vase
 1736–7. Oil on canvas shaped at the top, 133.5 x
 91.5 cm. London, National Gallery

HENDRICK TER BRUGGHEN
(c.1588 – 1629)
The Flute Player

1621. Oil on canvas, 70 x 55 cm. Kassel, Gamäldegalerie

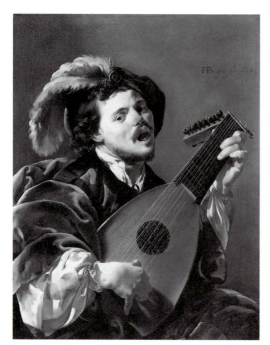

Fig. 11
HENDRICK
TER BRUGGHEN
The Singing
Lute-Player
1624. Oil on canvas,
100.5 x 78.7 cm. London,
National Gallery

Hendrick ter Brugghen was a highly original painter. He was probably born in Utrecht, where he was a pupil of the Mannerist history painter, Abraham Bloemaert. Having learnt the basic skills of his craft in Bloemaert's workshop, he set off for an extended stay in Italy, a practice which was quite usual among Dutch artists – and especially those from the Catholic city of Utrecht – in the early seventeenth century. Ter Brugghen seems to have been based in Rome. It was a time of hectic activity and experiment: the young painter from Utrecht studied the work of the Carracci, Domenichino and Guido Reni, but the artist who was to have the most profound effect on him was Caravaggio, who fled from Rome after killing a man in 1606 and died four years later at Porto Ercole. Caravaggio's powerful, even shocking, naturalism and his dramatic use of bold highlights and deep shadows particularly excited the young ter Brugghen. After Caravaggio's death, his revolutionary style was adopted and developed in the direction of more decorative effects by a group of Italian followers, among them Orazio Gentileschi and Bartolomeo Manfredi. Ter Brugghen was arguably the leading member of a group of young Utrecht artists who were profoundly influenced by the work of Caravaggio and his Italian followers: they have been collectively christened the Dutch *Caravaggisti*. Gerrit van Honthorst and Dirk van Baburen followed the same route as ter Brugghen and had the same transforming experience. Together they fashioned a new type of history painting which was to change the course of large-scale narrative painting in the north and, in particular, affect Rembrandt's treatment of biblical subjects. Ter Brugghen was the first of the Dutch *Caravaggisti* to return home and bring the gospel of Caravaggism to the Netherlands: he was back in Utrecht by 1615. He died young, in 1629, but in the years after his return from Italy he developed a striking and original manner of painting and range of subject-matter. Following the example of Gentileschi and Manfredi, he painted half-length figures of drinkers and musicians, of which *The Flute Player* is an outstanding example. He also painted more ambitious multi-figured secular subjects, such as *The Concert* (London, National Gallery) of about 1626, based on Italian Caravaggesque prototypes. In *The Concert* he brings to an existing format of half-length figures gathered together around a flickering candle, a striking fluency in modelling the soft edges of his forms and a remarkable subtlety of palette – which includes light blues, lemon, purple and cerise.

HERCULES SEGERS (c.1589 – after 1633)
A River Valley with a Group of Houses

c.1625. Oil on canvas, 70 x 86.6 cm. Rotterdam, Boymans-van Beuningen Museum

Hercules Segers is best known today as an innovative printmaker. In the most recent catalogue 54 etchings are listed, with only 183 impressions in all: this unusually small number was a consequence of Segers's unconventional and painstaking working procedure. He regarded each impression as a unique work of art, often printing impressions on rare papers and fabrics (including silk). According to the painter-critic Samuel van Hoogstraten, Segers 'printed ... paintings'. There are relatively few paintings by Segers. There are four (or possibly five) signed pictures and a group of others which can be assigned to him with confidence on the basis of comparison with these and the etchings.

In this painting of about 1625 Segers combined views familiar to him in an imaginary setting. The landscape was formerly identified as the valley of the River Maas (Meuse) and while it is not topographically accurate, it is probably based on his memories (presumably recorded in the form of sketches) of a trip along the Maas where high, rocky mountains can be found rising from the flat meadows bordering the river. The houses in the foreground are those which Segers saw from the window of his house on the Lindengracht in Amsterdam: it was a view which the artist etched. The placing of actual buildings into an imaginary landscape was not peculiar to Segers: other seventeenth-century Dutch artists, among them Salomon van Ruysdael, Jan van Goyen and Aelbert Cuyp, also transposed well-known structures into an invented setting.

Segers worked in Amsterdam but is recorded towards the end of his life in both Utrecht and The Hague. He seems to have enjoyed little contemporary success and is cited by van Hoogstraten as an example of an artist who was treated badly by fortune and whose true worth was discovered only after his death. He related that Segers, despairing of ever achieving success, took to drink and died after falling downstairs while drunk. His exact date of death is unknown: he is last recorded living in The Hague, active as an art dealer, in January 1633.

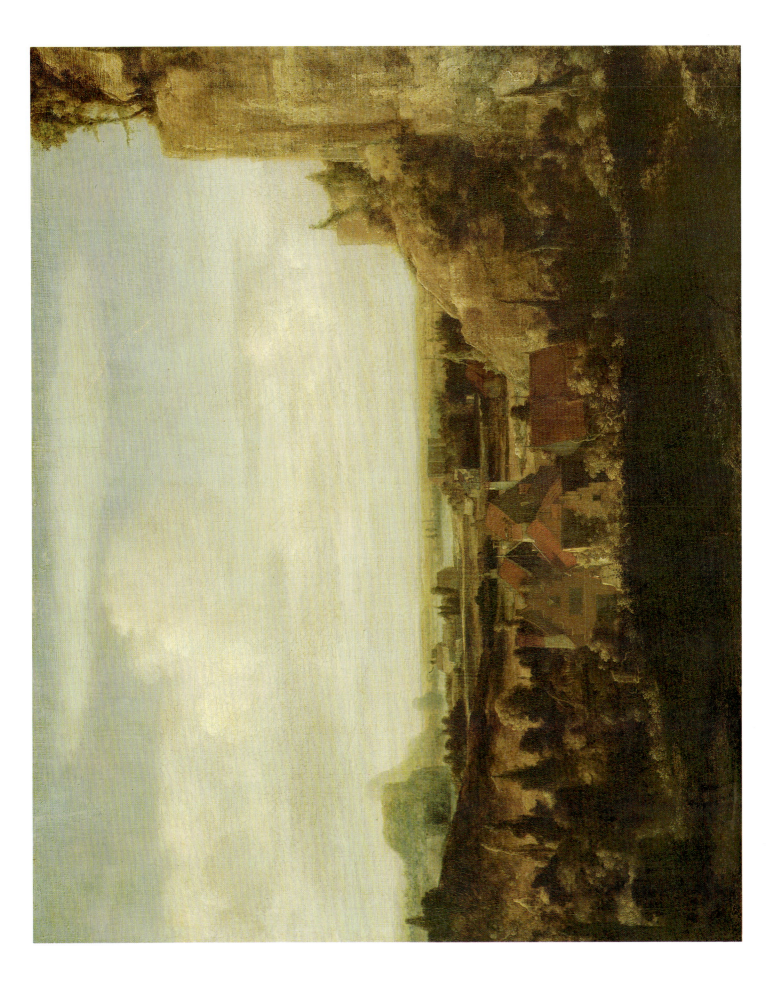

HENDRICK AVERCAMP (1585 – 1634)
A Scene on the Ice near a Town

c.1615. Oil on wood, 58 x 89.8 cm. London, National Gallery

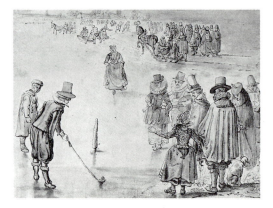

Fig. 12
HENDRICK
AVERCAMP
Golf on the Ice
Pen and brown ink,
watercolours on white
paper, 17.8 x 23.8 cm.
Windsor, Royal Collection

Hendrick Avercamp was known as *de stom van Kampen* (the mute of Kampen) because he was dumb. He was baptized in the Old Church in Amsterdam on 27 January 1585 but in the following year his parents moved to Kampen where his father was the town apothecary. Avercamp seems to have trained in Amsterdam with Pieter Isaacsz., who was a history painter, portraitist and draughtsman in an elegant, late Mannerist style quite unlike that of Avercamp. Avercamp's manner is based in the first place on that of the Flemish followers of Pieter Bruegel the Elder and he presumably came into contact with some of his followers who had settled in Amsterdam, such as David Vinckboons. Avercamp developed the style of Bruegel and Vinckboons in the direction of more decorative effects, creating scenes crammed with small figures and full of incident. He also possessed a refined sense of colour, carefully placing pinks, reds, blacks and whites with touches of yellow and green to create delicate and subtle effects. He principally painted winter scenes and made many watercolours of these and of fishermen and peasants: a large group of these watercolours is in the Royal Collection.

There are dated paintings by Avercamp from 1608 until 1632 but they show relatively little development in style: the earlier paintings are more 'Flemish', that is, closer to Bruegel and his followers, but once he had mastered a successful style Avercamp saw little need to change it substantially. The dating of paintings which do not bear a date is therefore difficult but this particular winter landscape appears to be from about 1615. It has been supposed that the building on the right is the Half Moon Brewery at Kampen but only a few barrels outside suggest it is a brewery, and the vaguely indicated town in the distance does not seem to be Kampen. The tower is closer to that of the Sint Cunerakerk in Rhenen.

Avercamp was buried in the Sint Nicolaaskerk in Kampen on 15 May 1634. His nephew, Barent Pietersz. Avercamp, who also lived and worked for much of his life in Kampen, was a close follower, as was Arent Arentsz. of Amsterdam.

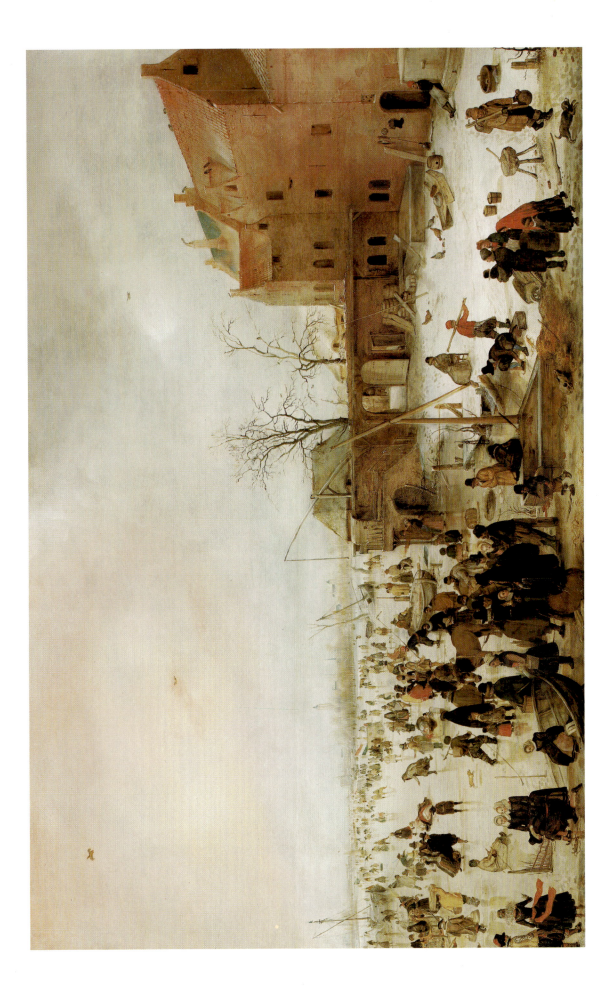

4

THOMAS DE KEYSER (1596 – 1667)
Constantijn Huygens and his Clerk

1627. Oil on wood, 92.4 x 69.3 cm. London, National Gallery

Thomas de Keyser lived and worked in Amsterdam and from the diary of the sitter, Constantijn Huygens, we know that Huygens was in Amsterdam between 22 February and 27 April 1627, the year on this portrait. It may well be 'my portrait painted shortly before my wedding' (which took place on 6 April 1627) about which Huygens wrote some Latin verses: he was then thirty-one. Two years earlier Huygens, who had previously been at the Dutch embassies in Venice and London, was appointed secretary to the Stadholder Prince Frederick Hendrick of Orange. Among his duties he had to advise the Prince on artistic matters and consequently Huygens is an important figure in the history of the art and architecture of the northern Netherlands in the seventeenth century. He was one of the first to recognize the talent of the young Rembrandt and gave him his most important early commission, a series of paintings of the Passion of Christ for the Prince's Noordeinde Palace in The Hague.

De Keyser shows Huygens as he sits at his desk in his house in The Hague, attended by a servant bringing a message. Behind him hangs a rich tapestry with his coat of arms in the centre of the border at the top: the central panel appears to depict Saint Francis before the Sultan. Above the mantelpiece is a marine painting in the style of Jan Porcellis, whom Huygens admired. On the table is a long-necked lute or *chitarrone*, referring to his interest in music, as well as books and architectural drawings. (He was a close friend of the great classical Dutch architect, Pieter Post, and with Post's help designed his own house in The Hague). The globes which can be seen beyond the table, indicate his interest in geography and astronomy. Huygens served successive Princes of Orange: he was first councillor and *reekenmeester* to the Stadholder-King William III until his death in The Hague in 1687.

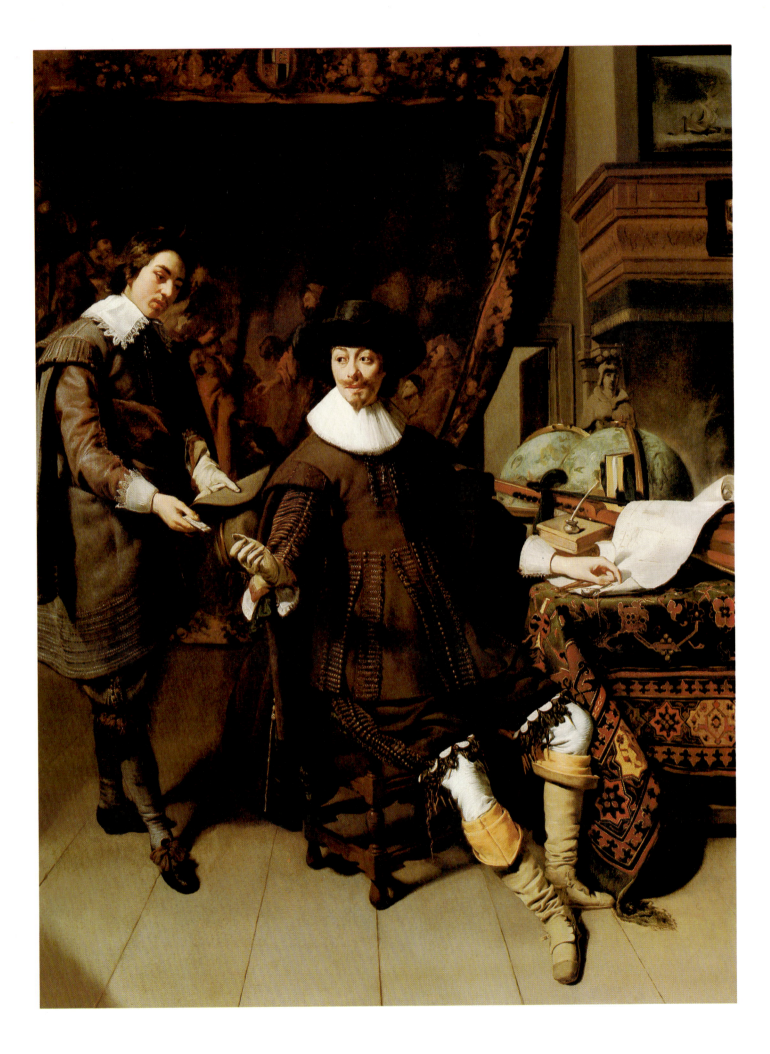

REMBRANDT VAN RIJN (1606 – 1669)
Jeremiah Lamenting the Destruction of Jerusalem

1630. Oil on panel, 58.3 x 46.6 cm. Amsterdam, Rijksmuseum

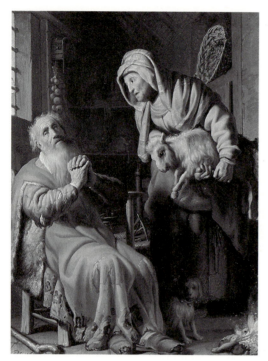

Fig. 13
REMBRANDT
VAN RIJN
Tobit and Anna
1626. Oil on wood,
39.5 x 30 cm. Amsterdam,
Rijksmuseum

After his initial training in his native town of Leiden, Rembrandt spent a short but crucially important period in the studio of the history painter Pieter Lastman in Amsterdam. He then returned to Leiden and set up as an independent painter in 1625. He worked in the town for about six years until settling permanently in Amsterdam. Rembrandt's early work shows the powerful influence of Lastman's broad, colourful style, as can be seen, for example, in the *Tobit and Anna* of 1626 (Fig. 13). This well-preserved painting is one of the finest works of Rembrandt's Leiden period. For many years it was incorrectly identified but it certainly shows Jeremiah, who had prophesied the destruction of Jerusalem, capital of Judah, by Nebuchadnezzar (Jeremiah, chapters 32, 33), lamenting over the destruction of the city. In the distance on the left a man at the top of the steps holds clenched fists to his eyes: this is the last king of Judah, Zedekiah, who was blinded by Nebuchadnezzar. The prominent domed building in the background is probably Solomon's Temple. Jeremiah's pose, his head supported by his hand, is a traditional attitude of melancholy: his elbow rests on a large book which is inscribed 'Bibel' on the edge of the pages, probably a much later addition to the painting. The book is presumably meant to be his own Book of Jeremiah or the Book of Lamentations. The lighting of the figure is particularly effective with the foreground and the right side of the prophet's face in shadow and his robe outlined against the rock. Rembrandt has used the blunt end of his brush to scratch details of the foliage, Jeremiah's beard and the fastenings of his tunic in the wet paint, a characteristic technique of his early years.

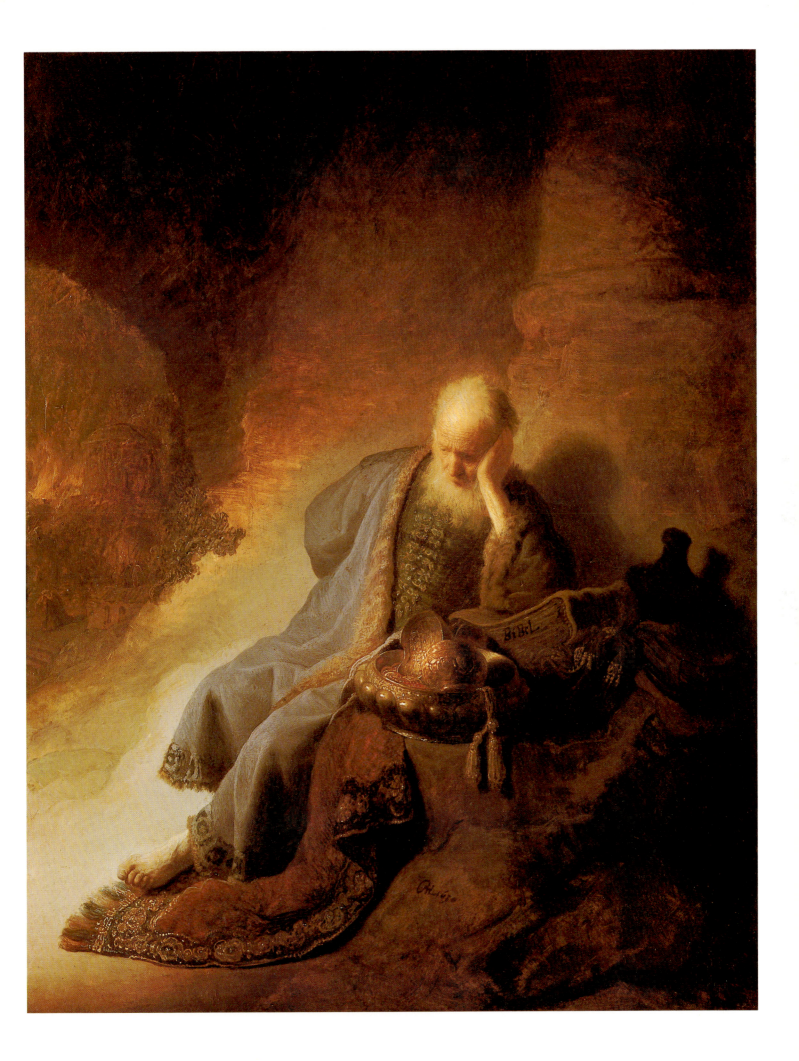

ESAIAS VAN DE VELDE (1587 – 1630)
A Winter Landscape

1623. Oil on panel, 25.9 x 30.4 cm. London, National Gallery

In 1612 two landscape artists, Hercules Segers (see Plate 2) and Esaias van de Velde joined the painters' guild in Haarlem, and it is from that year that the origins of realistic landscape painting in the north Netherlands can be dated. Esaias was born in Amsterdam in about 1590 and probably trained in the studio of Gillis van Coninxloo, an Antwerp landscape painter and follower of Pieter Bruegel the Elder, who had fled to the north as a Protestant refugee from the war in Flanders. Esaias van de Velde developed Coninxloo's style in the direction of greater realism. As can be seen in this small panel of 1623, his mature style is characterized by a striking naturalism created by free brushwork and a deliberately restricted palette. The mannerisms of Flemish landscape have disappeared to leave an image which conveys all the crispness of an icy winter day in Holland. The figures are sketched in sure, quick strokes, the landscape evoked in pigments thinly scraped across the still-visible gesso ground. Van de Velde also studied the work of Adam Elsheimer, the German painter who moved to Rome in the first decade of the seventeenth century. Esaias would have known Elsheimer's paintings in the form of prints and it is from them that he derives his low viewpoint and the triangular composition.

At the same time as the powerful and naturalistic landscapes of Segers and Esaias van de Velde were being created in Haarlem, Esaias's cousin, Jan van de Velde, was at work in the town engraving his delicate landscapes, and Cornelis Vroom was creating his understated but remarkably innovative paintings and prints based on the countryside around the town (see Fig.13). Among Esaias's pupils was Jan van Goyen who was further to develop and refine his master's style (see Plate 7).

Fig. 14
CORNELIS
VROOM
A Landscape with
a River by a Wood
1626. Oil on wood,
31.2 x 44.2 cm. London,
National Gallery

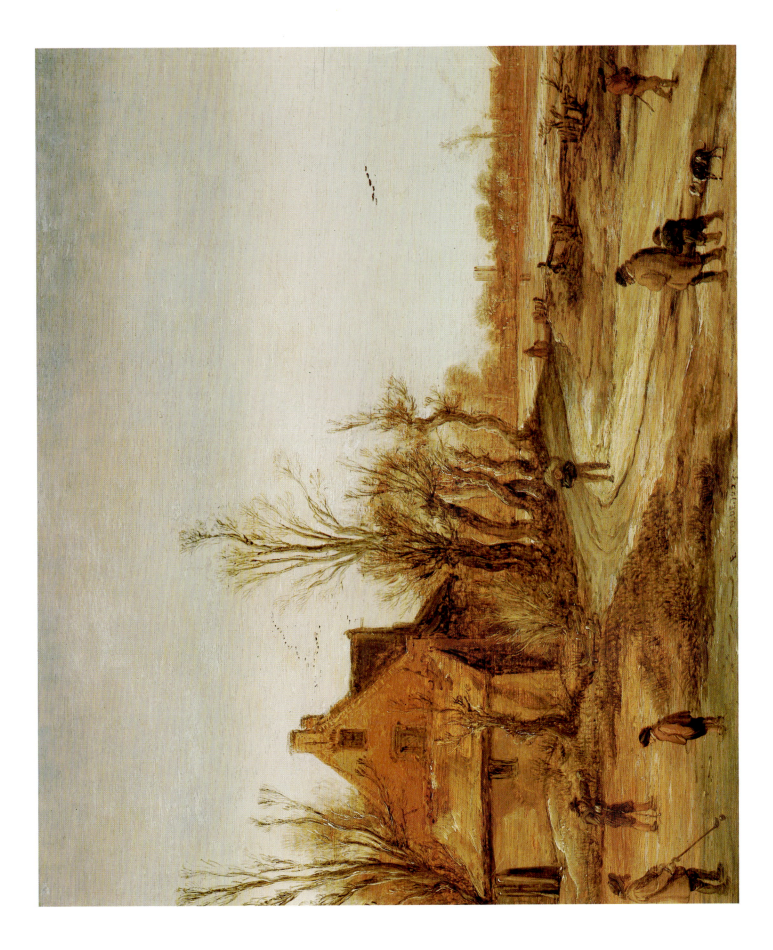

JAN VAN GOYEN (1596 – 1656)
Haarlemer Meer

1656. Oil on canvas, 39 x 54 cm. Frankfurt, Städelsches Kunstinstitut

Jan van Goyen was born in Leiden and trained in the studios of a succession of local artists. His most influential teacher, however, was Esaias van de Velde in whose Haarlem studio he spent a year before establishing himself as an independent painter in his native town. Subsequently van Goyen worked in The Hague and Haarlem.

In his earliest landscapes – his first dated painting is from 1618 – van Goyen employed the highly coloured, strongly linear technique of Esaias van de Velde, but progressively his paintings become less colourful and less crowded with figures. He shared this move towards a deliberately restricted palette of blues, greys, greens and blacks, and simple compositions, with the Haarlem landscape painters, Pieter Molijn and Salomon van Ruysdael. In the work of all three painters the sky assumes greater and greater importance, as in this painting in which it occupies almost three-quarters of the picture surface. The clouds are painted thinly over the prepared ground of the panel which gives a warm undertone. In this view of Haarlemer Meer, a vast inland lake which was not drained until the nineteenth century, the Great Church at Haarlem can be seen on the horizon in the far right-hand corner. This atmospheric study of clouds and still water was painted in the last year of the artist's life.

With his linear style it is no surprise to discover that van Goyen was an indefatigable draughtsman. More than 800 drawings and several sketchbooks, all in his favourite medium of black chalk and wash, are known today. Many are quick sketches made from nature during his travels in the north Netherlands and Germany, which in the studio were transformed into imaginative landscapes. His rapid painting technique enabled him to be a prolific artist: more than twelve hundred paintings from his hand survive.

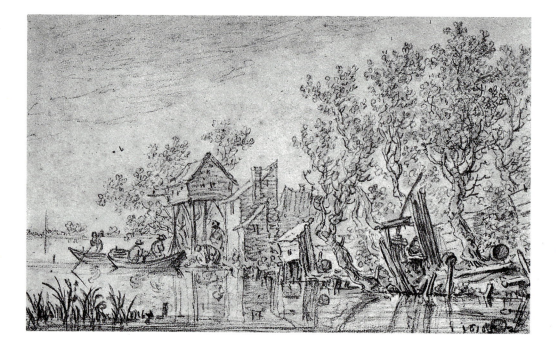

Fig. 15
JAN VAN GOYEN
Canal Landscape
Black chalk and wash.
Paris, Musée du Louvre

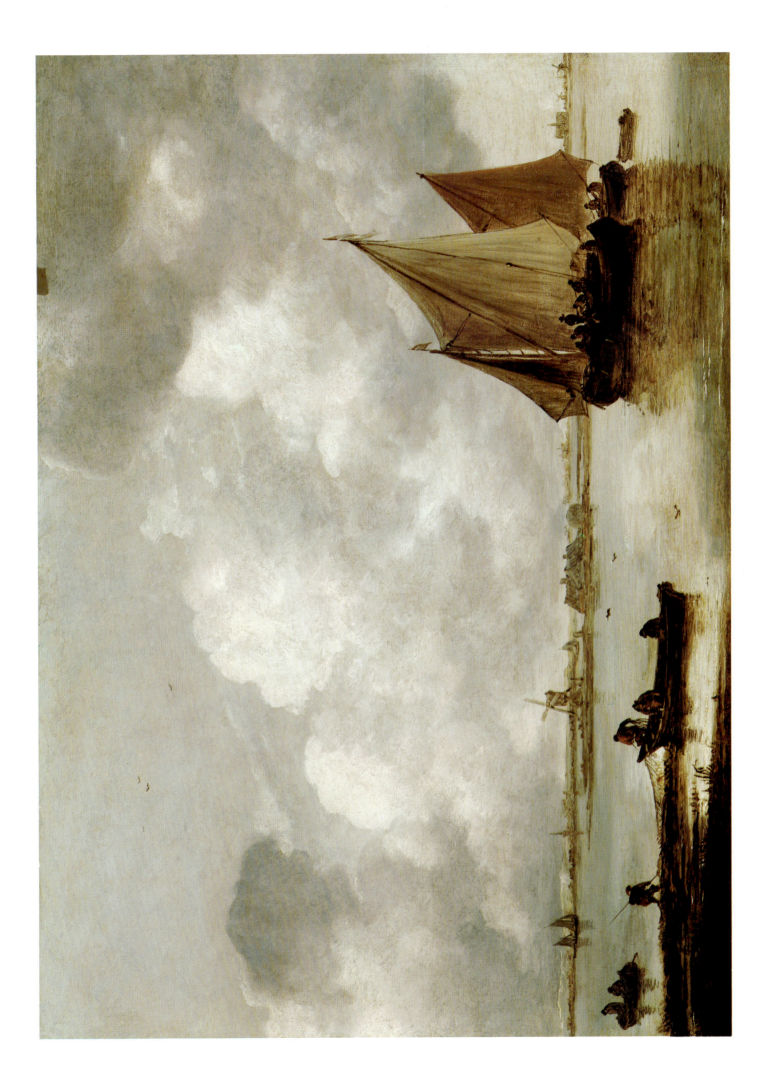

8

FRANS HALS (c.1580 – 1666)
Pieter van den Broecke

c.1633. Oil on canvas, 71.2 x 61 cm. London, Kenwood House, The Iveagh Bequest

In this portrait there is a perfect match of a painter's style to the sitter. Hals's bold, direct manner is ideally suited to portrayal of the Antwerp-born colonial trader Pieter van den Broecke (1585-1640) who lived in Haarlem. He was first active as a merchant in West Africa and subsequently served the Dutch East India Company in Java, Arabia, Persia and India. In 1630 he brought back to the Netherlands an important fleet from India and was rewarded by the Dutch East India Company for his seventeen years of service with a gold chain worth 1200 guilders. It is this chain which he proudly wears in the portrait.

In 1634 van den Broecke published an account of his exotic career which presents a purposeful and straightforward man who was typical of the aggressive entrepreneurs who shaped the Dutch commercial empire. This portrait, with its thrusting and confident pose, gives a similar impression and it is not surprising to find that it was used, in the form of an engraving by Adriaen Matham, as the frontispiece of van den Broecke's book. Van den Broecke knew Frans Hals well, acting as a witness at the baptism of Hals's daughter, Susanna, in 1634. The second witness was one Adriaen Jacobsz., almost certainly the Adriaen Matham who engraved the portrait for van den Broecke's autobiography.

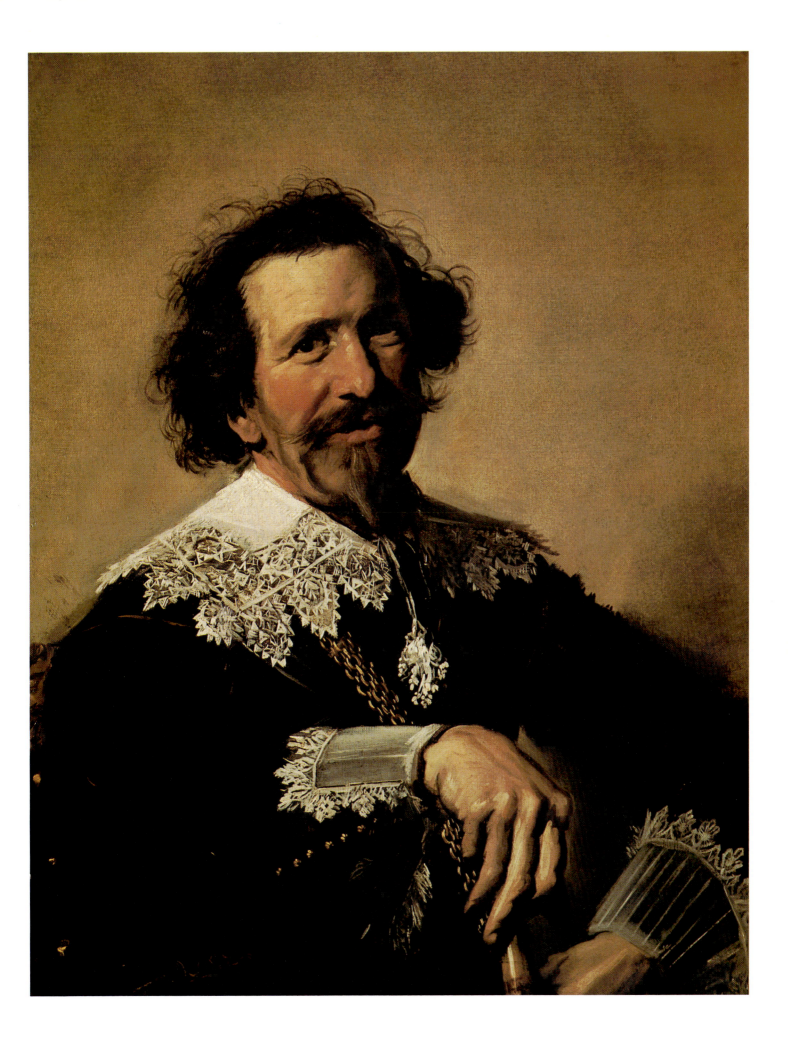

9 JOHANNES VERSPRONCK (c.1606 – 1662)
Girl in a Blue Dress

1641. Oil on canvas, 82 x 66.5 cm. Amsterdam, Rijksmuseum

Johannes Verspronck was born in Haarlem in about 1606 and trained in
the studio of his father, Cornelis Engelsz., who painted portraits, kitchen
still lifes and genre scenes. He joined the guild of St Luke in 1632 and
spent his entire life as a portrait painter of his fellow townsmen. He was
more than twenty years younger than Frans Hals and may have worked in
his studio. He was certainly powerfully influenced by Hals's bold, linear
style and his assertive poses. However, Verspronck's technique is less
sketchy, his heads more elaborately worked up: he works in a more
refined and detailed manner. His most imposing works are the two group
portraits of 1641 and 1642 of the Regentesses of the St Elizabeth Hospital
which form a counterpart to the portrait of the Regents of the same insti-
tution painted by Hals in the same years. All three paintings hang today in
the Frans Halsmuseum in Haarlem.

This subtle and charming portrait of a young girl holding an ostrich-
feather fan is one of Verspronck's most outstanding works. The delicately
modelled face and the careful detailing of the dress and jewels set it apart
from the work of Hals and give it a quite individual and striking effect.

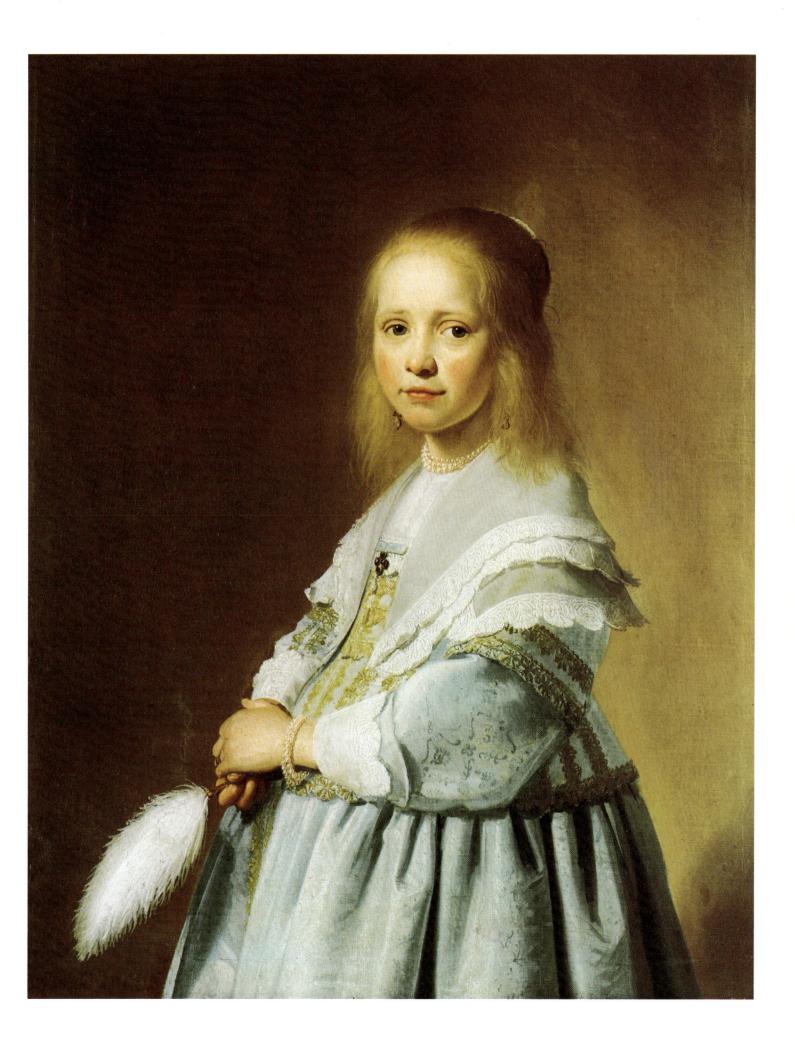

JAN VAN DER HEYDEN (1637 – 1712)
Approach to the Town of Veere

c.1665. Oil on panel, 45.7 x 55.9 cm. London, Buckingham Palace

Jan van der Heyden, who specialized in the painting of townscapes, was born in Gorinchem but moved as a child to Amsterdam. He is said to have been trained by a glass-painter, an apprenticeship which taught him to paint with the extraordinary degree of precision evident in his topographical views. He lived and worked in Amsterdam throughout his life but travelled widely in Holland, Flanders and the Rhineland. He painted many of the towns he visited, producing more that one hundred views of identified places in Holland, as well as of Brussels and Cologne. From the end of the 1660s he was also involved in projects to improve street-lighting and fire-fighting in his native town and provided the illustrations for books on these subjects. In addition to town views, he painted a few landscapes and still lifes.

In the seventeenth-century Veere, a small town in the province of Zeeland, on the strait between Walcheren and Noord Beveland, was an important port which carried on an extensive trade with Scotland. It is seen here from the south-west with the tower of the Great Church prominent on the left: the church was extensively damaged by fire in 1686. Traditionally the figures have been attributed to Adriaen van de Velde but in fact are probably by van der Heyden himself. The artist painted a number of views of the town of Veere seen from slightly different points of view but none are dated and there is no record of when van der Heyden visited the town. There is relatively little development in van der Heyden's meticulous and delicate style and his paintings are therefore difficult to date with any precision, but this view was probably painted around 1665.

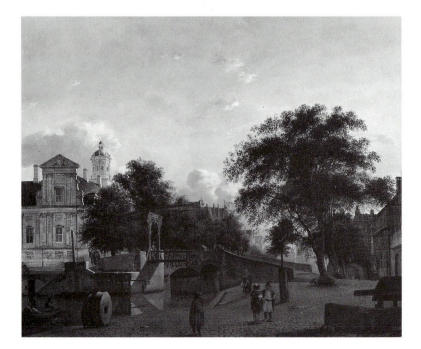

Fig. 16
JAN VAN DER
HEYDEN
View in Amsterdam
Oil on wood,
44 x 54.4 cm. Richmond,
Virginia, Virginia Museum
of Fine Arts

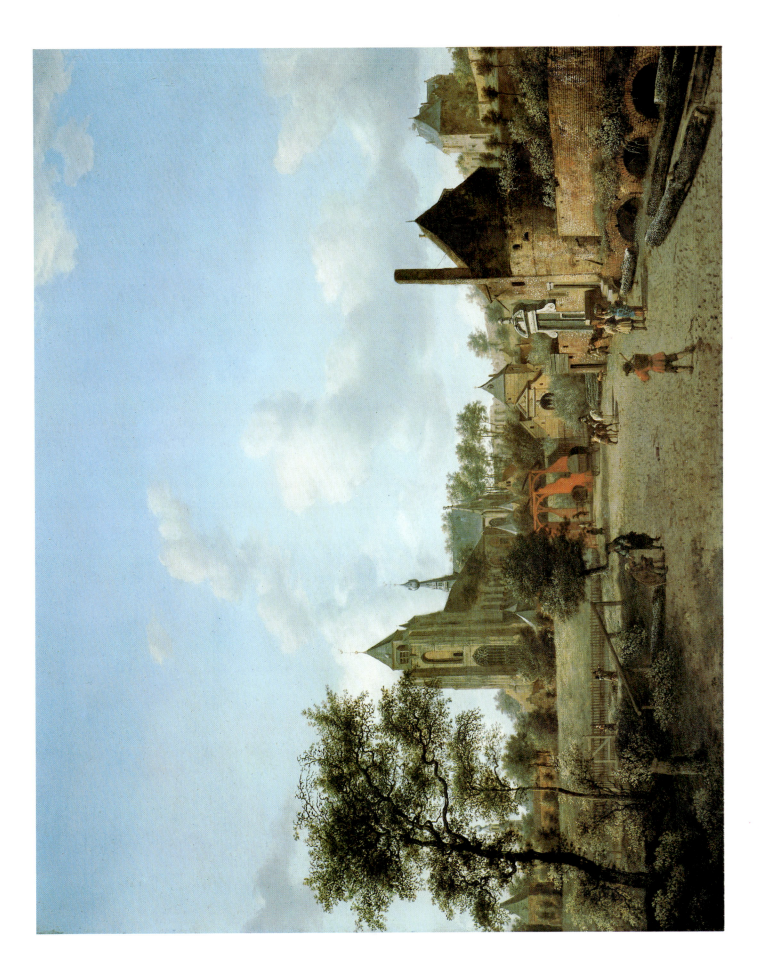

11

PIETER JANSZ SAENREDAM
(1597–1665)
St Mary's Square and St Mary's Church
at Utrecht

1662. Oil on wood, 109.5 x 139.5 cm. Rotterdam, Boymans-van Beuningen Museum

In this outstanding architectural view, painted three years before the artist's death and one of the masterpieces of his maturity, Saenredam shows the almost deserted Mariaplaats on a quiet summer's afternoon. The twelfth-century Mariakerk is on the right: in the middle of the Gothic rose window in the Romanesque facade is the golden crown commemorating Emperor Hendrick IV (1050–1106). On the left is a high wall with gates which opened onto the gardens of houses belonging to the deans of the chapter of St Mary. In the background is a row of houses with stepped gables and rising above them are the towers of the Buurkerk on the left, with its wooden roof, and the Cathedral, with its slender octagonal lantern. The painting is signed and dated above the door of the church.

Pieter Saenredam, the son of the distinguished engraver Jan Saenredam, was a painter of church interiors and topographical views. Born in Assendelft, he was taken as child to Haarlem and remained there for the rest of his life, entering the guild as a master in 1623. He made very precise architectural drawings which he then transferred to panel or canvas, sometimes making small modifications for compositional reasons. As was his usual method of work, Saenredam based this painting on a detailed drawing made (as he notes in a lengthy inscription) 'from life' on 18 September 1636, in brown ink and watercolour. (The drawing is today in the Teylers Museum, Haarlem.) Saenredam, using the drawing twenty-six years after he had made it, drew a grid on the panel in order to transfer the composition from the drawing to scale. In some areas of the picture, for example beneath the rose window, the construction lines can be seen through a thin layer of transparent paint.

12

JACOB VAN RUISDAEL (c.1628 – 82)
The Castle at Bentheim

1651. Oil on canvas, 97.7 x 81.3 cm. Norfolk, Private Collection

Jacob van Ruisdael, the greatest of all Dutch seventeenth-century land-scape painters, was born in Haarlem. He was a member of a dynasty of artists and was trained in the studios of his father, Isaac Jacobsz. van Ruisdael and his uncle, Salomon van Ruysdael. Salomon worked in the 'monochrome' Haarlem style of which Jan van Goyen (see Plate 7) and Pieter Molijn were also practitioners, and Jacob's earliest paintings display a powerful debt to his uncle's work. He joined the Haarlem guild in 1648 and two years later travelled with his friend Nicolaes Berchem, a painter of Italianate landscapes (see Plate 46), to the German border. There they visited Bentheim, a small town in Westphalia on the border between the United Provinces and Germany. They both sketched Bentheim Castle and later worked up their drawings into paintings. Indeed Ruisdael, whose imagination was particularly inspired by Bentheim, made a whole series of paintings of the castle perched dramatically on an outcrop of rock. Ruisdael's and Berchem's views of Bentheim provide a fascinating comparison between the two artists and their approach to landscape: whereas in a painting of 1656 (now in Dresden) Berchem turned the castle into a fairy-tale cluster of pinnacles and placed it in the shimmering distance behind a scene of carefree Italian peasants watering their cattle, Ruisdael transformed the low hill on which the castle sits into a sheer cliff, topped by a granite fortress.

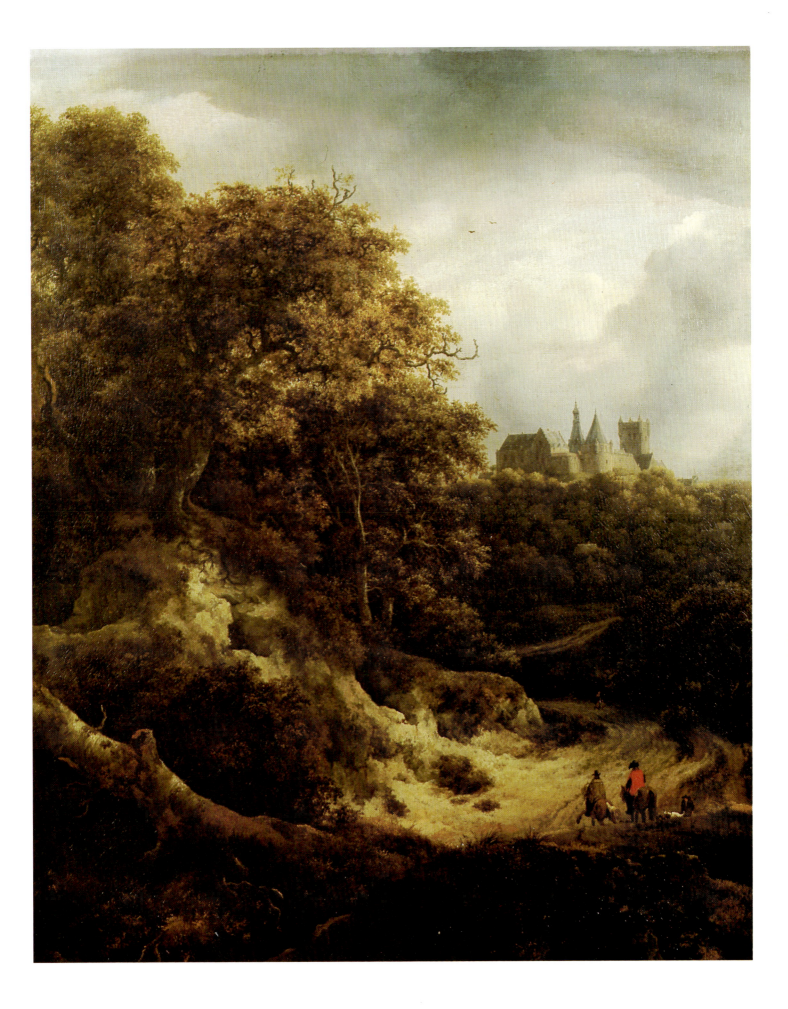

REMBRANDT VAN RIJN (1606 – 69)
Christ and the Woman Taken in Adultery

1644. Oil on panel, 83.8 x 65.4 cm. London, National Gallery

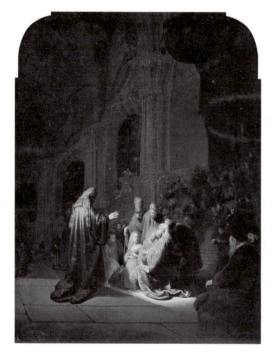

Fig. 17
REMBRANDT
VAN RIJN
The Presentation
in the Temple
1631. Oil on panel,
61 x 48 cm. The Hague,
Mauritshuis

Christ's forgiveness of the adultress is described in the Gospel of St John, chapter 8. Rembrandt shows the moment at which the Pharisees, attempting to outwit Jesus, ask him whether, in accordance with the Mosaic law, she should be stoned to death. Jesus replies 'He that is without sin among you, let him cast the first stone'.

The painting is an outstanding example of Rembrandt's gifts as a colourist, an aspect of his art which is sometimes forgotten. Within the dark interior of the temple, golds, reds, greens and browns glow as they are struck by a strong fall of light. In some respects this is an unusual painting for its date, 1644, in that the composition – the small figures dwarfed by the cavernous space of the temple – as well as the elaboration of detail and the degree of finish, especially in the background, hark back to the style of paintings of a decade earlier (such as *The Presentation in the Temple* of 1631, Fig 17). However, the broader treatment of the foreground figures is consistent with Rembrandt's greater freedom of handling in the 1640s and, above all, the quieter, restrained mood of the picture and its size accord with a move away from the intensely dramatic, large-scale Biblical scenes of a few years earlier.

The painting has an interesting history. It was almost certainly the painting of this subject which, at 1500 guilders, was the highest valued item in the inventory of the Amsterdam art dealer, Johannes de Renialme, drawn up in 1657. Subsequently it was owned by the Six family until sold to a dealer in 1803. Four years later it was sold in London to John Julius Angerstein whose paintings, purchased by the British government in 1824, formed the basis of the National Gallery's collection.

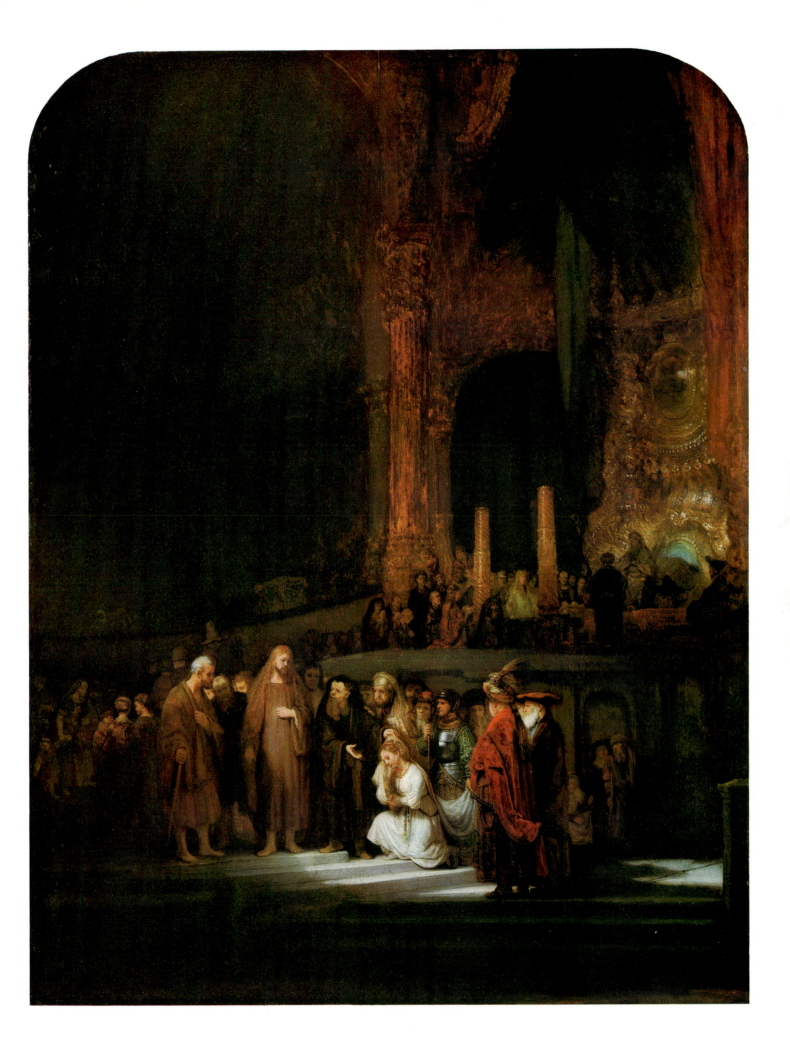

REMBRANDT VAN RIJN (1606 – 69)
Agatha Bas

1641. Oil on canvas, 104 x 82 cm. London, Buckingham Palace

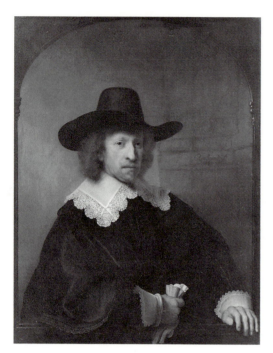

Fig. 18
REMBRANDT
VAN RIJN
Portrait of Nicolaes
van Bambeeck,
Husband of
Agatha Bas
1641. Oil on canvas,
108.8 x 83.3 cm. Brussels,
Musée Royal des
Beaux-Arts

Agatha Bas (1611–58) was a member of one of Amsterdam's leading families, the middle daughter of Dirk Jacobsz. Bas, a director of the Dutch East India Company who had served as burgomaster of the city on several occasions. She married Nicholas van Bambeeck (1596 – 1661), a successful cloth merchant who was an immigrant from Flanders, when she was twenty-seven. Rembrandt had probably known Bambeeck for some time before he painted both his portrait (Fig. 18) and the companion portrait of Agatha. In 1631 Bambeeck was living in the Sintanthonisbreestraat, where Rembrandt was also staying in the house of the art dealer Hendrick van Uylenburgh; both Rembrandt and Bambeeck invested in Uylenburgh's business in 1640.

The pair of canvases depicting Bambeeck and his wife are superb examples of the accomplished and imposing portraits bathed in soft light which Rembrandt was painting in the years around 1640. He placed both husband and wife in illusionistic painted frames, an effect heightened by the cloak and glove seemingly hanging over the edge of the frame in Nicholas's portrait, and the fingers of Agatha's left hand which appear to project beyond the frame here. Unfortunately both paintings have been cut down at the top and sides, removing part of the painted frames and so weakening the *trompe l'oeil* effect. Originally the portraits would have been shown in arched ebony frames, echoing their painted counterparts, and so further merging painted appearances and reality. The paintings hung together until they were sold in London in 1814. *Agatha Bas* was bought in 1819 by Lord Yarmouth acting for the Prince Regent and so entered the Royal Collection. *Nicolaes van Bambeeck* was purchased by the Musée Royale des Beaux-Arts, Brussels, in 1841.

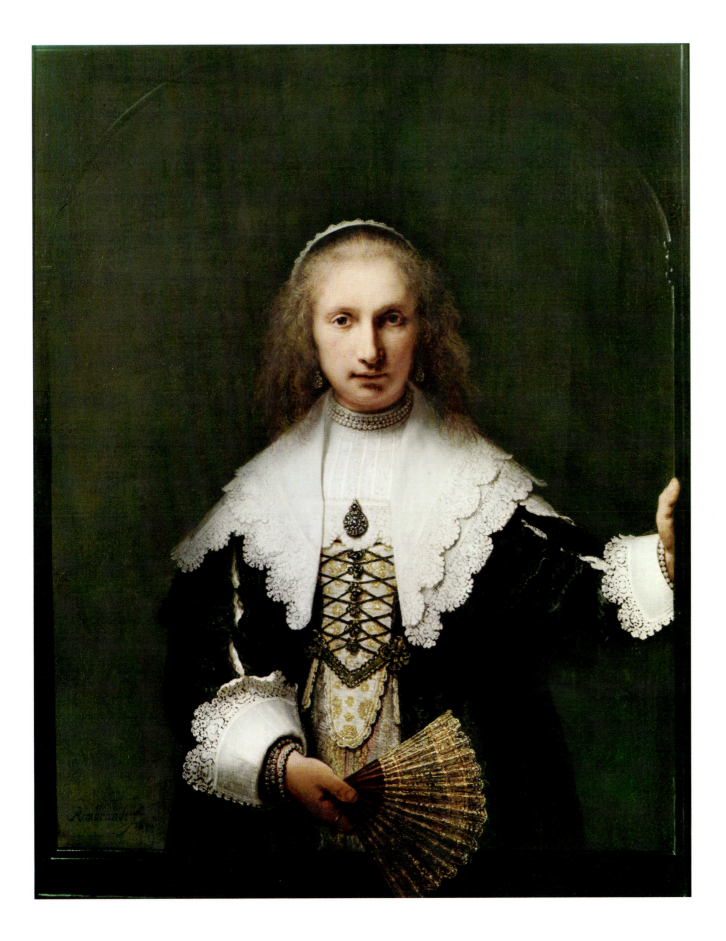

GABRIEL METSU (1629 – 67)
The Sick Child

c.1660. Oil on canvas, 33.2 x 27.2 cm. Amsterdam, Rijksmuseum

Gabriel Metsu was born in Leiden, the son of a Flemish painter who had emigrated to the north. He was a pupil of Gerrit Dou, a painter of genre scenes and the founder of the so-called *fijnschilder* school of painting, whose work is characterized by its very high finish. Metsu was one of the founder members of the Leiden guild in 1648 but by 1657 was living in Amsterdam. Like so many artists from smaller towns (including Rembrandt, who also came from Leiden) he was drawn to the metropolis by its thriving art market and the hope of lucrative commissions. Metsu is a fascinating and eclectic artist whose work at different times shows the influences of Jan Steen, Nicolaes Knüpfer, Gerard ter Borch, and his master Gerrit Dou.

Most of Metsu's paintings are genre scenes but he also painted religious subjects (including a notable *Noli Me Tangere* of 1667, now in Vienna) as well as a few portraits, still lifes and game pieces. This particular painting is a genre scene and yet the pose of the child on her mother's knee is reminiscent of that used to depict the Infant Christ in Mary's lap. These religious resonances are deepened by the small black-framed painting of the Crucifixion which hangs on the wall above the figures. Metsu's technique is quite different from that of his master: the mother and child are broadly painted with a rich, almost succulent application of paint. His palette too is bolder and more varied than Dou's. In all, there is a similarity with contemporary Flemish painting and even echoes of pictures of the Virgin and Child by Anthony van Dyck.

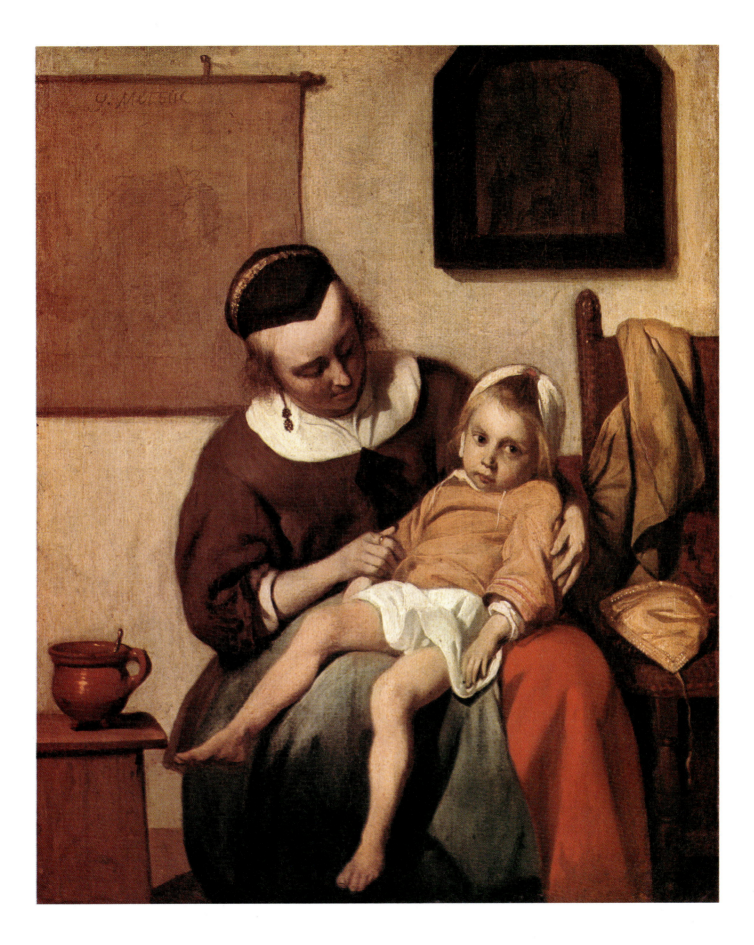

MICHIEL SWEERTS (1624 – 64)
The Drawing Class

c.1656–8. Oil on canvas, 76.5 x 110 cm. Haarlem, Frans Halsmuseum

Fig. 19
MICHIEL
SWEERTS
In the Studio
Oil on canvas,
73.5 x 58.8 cm. Detroit, Detroit
Institute of Arts

Sweerts was born and trained in Brussels: he spent several years in Rome but was back in Brussels by 1656 when he received permission to open an academy in the city. He joined the guild in Brussels in 1659 but two years later travelled to the Far East as a member of a Catholic missionary expedition. He died in Goa in 1664.

Sweerts painted a number of pictures showing young artists drawing from plaster casts and drawing from life outside the studio, but this is his only painting of an academy. The work has a special significance in Sweerts's life as we know that he ran an *academie van die teeckeninghen naer het leven* (an academy for drawing from the life) in Brussels. While learning to draw from the antique and from models in his master's studio was a part of every Dutch and Flemish apprentice artist's training, academies of this type were rare in the Netherlands. Among the few precedents were those set up by Cornelis Cornelisz. van Haarlem, Hendrick Goltzius and Carel van Mander in Haarlem around 1590, and by Hendrick van Uylenburgh in Amsterdam in the 1620s. Sweerts, having lived in Italy for several years, presumably had Italian prototypes in mind such as the academy established by Baccio Bandinelli in 1531 in the Belvedere in Rome. Around the same time that he applied to open his academy, Sweerts made a series of etchings to be used in teaching young students to draw. Sadly, nothing more is known of Sweerts's academy.

JAN STEEN (c.1625 – 79)
The Village School

c.1670. Oil on canvas, 83.8 x 109.2 cm. Edinburgh, National Gallery of Scotland

Jan Steen was born in Leiden but is said to have studied with Nicolaes Knüpfer in Utrecht, Adriaen van Ostade in Haarlem and Jan van Goyen, whose daughter he married in 1649, in The Hague. He continued to move from town to town, being recorded in The Hague, Leiden and Delft during the course of his career. He was an enormously prolific painter who concentrated on lively genre scenes, although he also painted portraits and religious and mythological subjects. His work, which is markedly uneven in quality, is characterized by a robust humour, a sense of theatre and, often, a moralizing intention.

Steen's *The Village School* is in the satirical tradition of Pieter Bruegel the Elder's print *The Ass at School* which illustrates a popular saying: 'Though an ass goes to school in order to learn, he'll still be an ass, not a horse, when he returns' (Fig. 20). In Steen's school there is little to be learnt from the short-sighted teacher who is so intent on sharpening his quill that he fails to notice the chaos around him. Some children who are keen to learn have gathered around the schoolmistress who corrects their spelling but others fight, sing, make fun of the teachers and even sleep. On the right a child hands a pair of spectacles to an owl, a familiar symbol of foolishness in Steen's work.

Fig. 20
PIETER VAN DER HEYDEN after **PIETER BRUEGEL**
The Ass at School
1557 (original drawing 1556).
Print, 22.8 x 29.4 cm.
London, British Museum

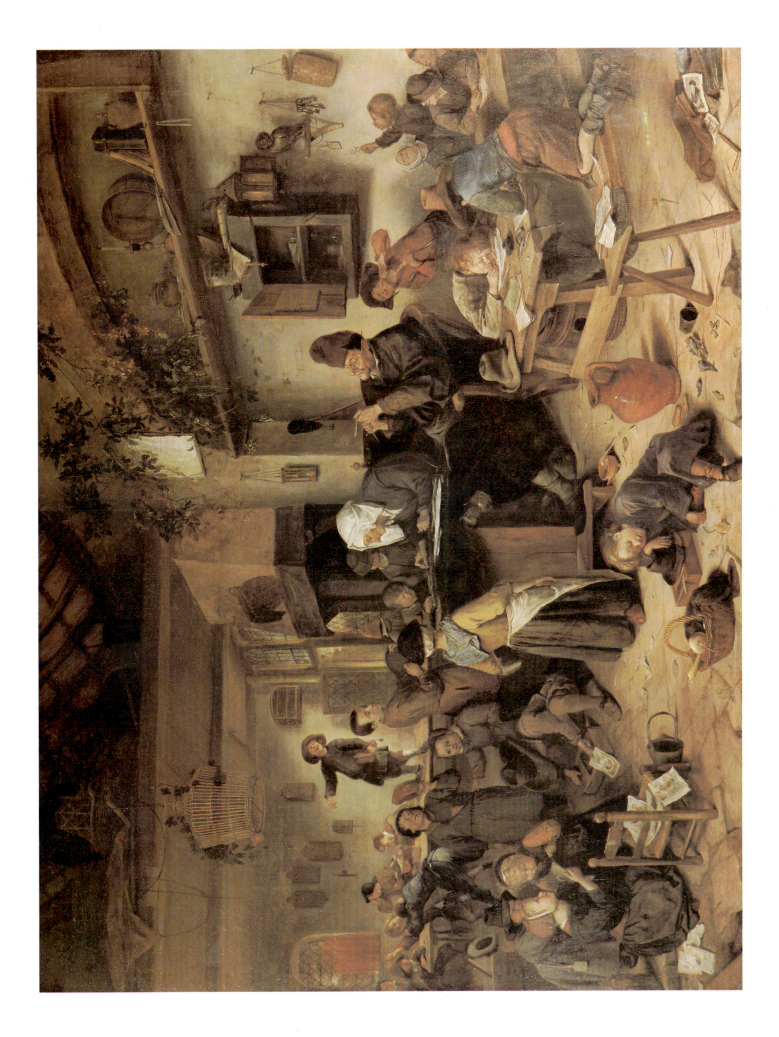

JOHANNES VERMEER (1632 – 75)
A Girl Reading at an Open Window

c.1657. Oil on canvas, 83 x 64.5 cm. Dresden, Staatliche Kunstsammlungen, Gemäldegalerie

Jan Vermeer, the greatest of all Dutch genre painters, lived and worked in his native town of Delft. The most likely candidate to have been his master is the history painter Leonaert Bramer, who testified to Vermeer's character at the time of his betrothal, but the artist's early work shows no trace of Bramer's influence. Vermeer's earliest dated painting, *The Procuress* of 1656 (now in Dresden), shows that he was familiar with the work of Utrecht followers of Caravaggio. This painting, also in Dresden, was painted shortly after *The Procuress* and its style is closely related to it, with its broad handling of paint, deep shadows and rich, saturated colours. The subject – a glimpse into the corner of a room where a young woman is totally absorbed in reading a letter – is quite unlike those painted by the *Caravaggisti*. Vermeer emphasizes the sense of our entering a private world by placing an illusionistic curtain on a rail in front of the scene. It was quite usual in Holland in the seventeenth century to protect paintings from sunlight and dust with such curtains. X-rays have revealed that the curtain was not part of Vermeer's original design. They also reveal that Vermeer made a number of other changes. He originally included a large painting of a standing Cupid hanging on the back wall, which would have suggested that it is a love letter that the girl reads. In the event he suppressed that element as well as making changes to the area of the figure's sleeve and hands.

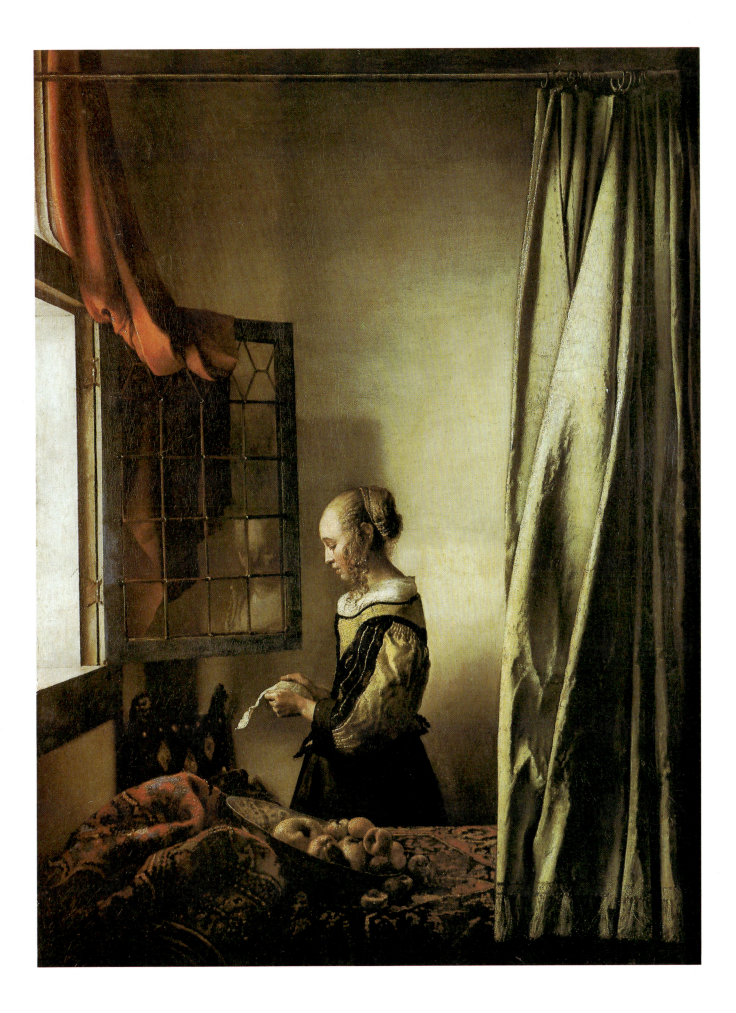

PIETER DE HOOCH (1629 – 1684)
The Courtyard of a House in Delft

1658. Oil on canvas, 73.5 x 60 cm. London, National Gallery

Fig. 21
PIETER DE
HOOCH
The Pantry
Oil on canvas,
65 x 60.5 cm. Amsterdam,
Rijksmuseum

Pieter de Hooch, born in Rotterdam in 1629 and trained in the Haarlem studio of the landscape painter Nicolaes Berchem, came to Delft in 1652. In the following year he was said to be in the service – both as a servant and a painter – of Justus de la Grange, a cloth merchant. De Hooch married in Delft in May 1654 and joined the painters' guild in September 1655. He remained in the town until 1661, when he moved to Amsterdam. In his early years De Hooch had painted scenes of soldiers and guard-rooms but after his move to Delft turned to genre scenes showing young men and women eating, drinking, playing musical instruments and flirting in well-appointed interiors. These are based on actual rooms in the houses of prosperous Delft citizens, carefully described in an effective empirical perspective. The earliest dated examples of De Hooch's Delft interiors are from 1658. He also painted a small number of closely related exterior scenes of which this painting, also from 1658, is the most outstanding example. It is unlikely to be a precisely accurate view as De Hooch used many of the same architectural elements in a second painting, also dated 1658, in which the right-hand side of the painting – where the maid and the child stand – was transformed to show a bower constructed with trellis-work beneath which two seated men and a standing woman drink and smoke. Both compositions are presumably based on quiet corners of Delft with which De Hooch was familiar. These and other paintings of De Hooch's Delft years evoke a world of quiet, domestic contentment, of pleasure taken in the performance of simple household tasks and in the appearance of well-ordered surroundings (Fig.21). It is an art which celebrates simple virtues, the efficient running of the home and the conscientious raising of children.

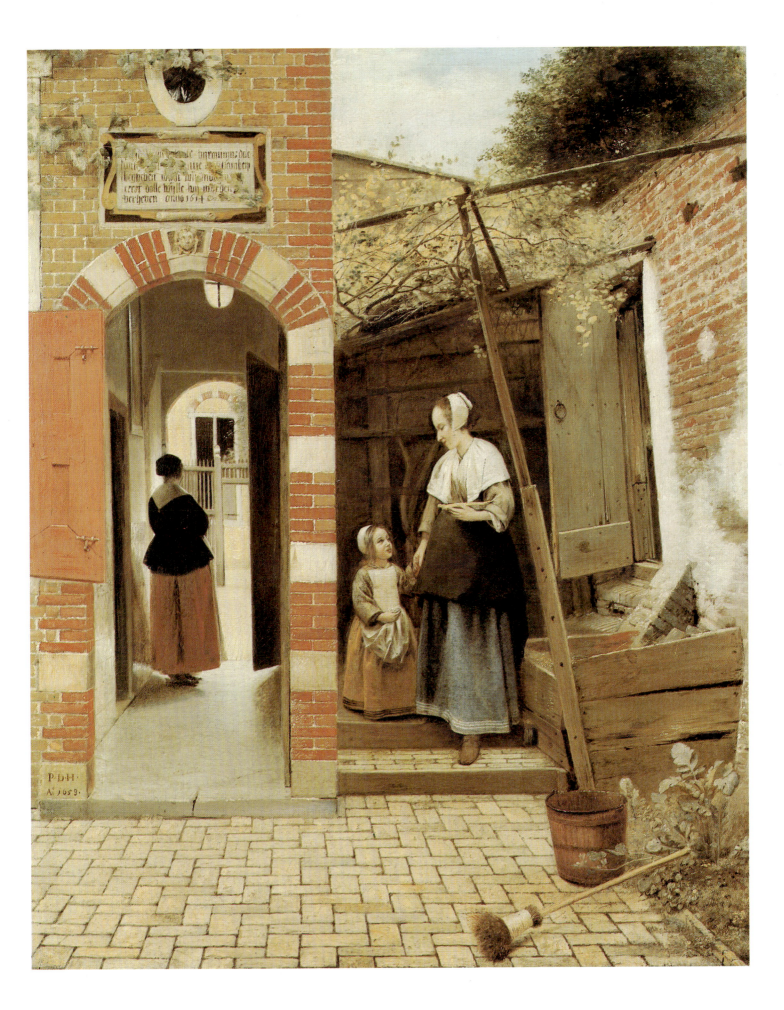

CAREL FABRITIUS (1622 – 54)
Self-Portrait

c.1645. Oil on wood, 65 x 49 cm. Rotterdam, Boymans-van Beuningen Museum

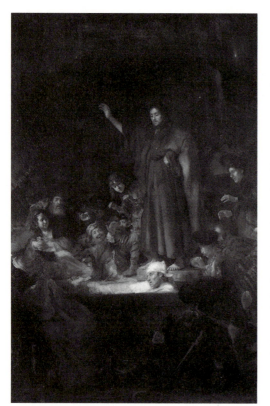

Carel Fabritius was Rembrandt's most outstanding pupil: he was a brilliant and experimental artist whose prodigious reputation rests on a handful of surviving paintings. Born in the village of Midden-Beemster and trained by his father, an amateur artist, Fabritius was in Rembrandt's Amsterdam studio in the years around 1640. His earliest known painting, *The Raising of Lazarus* (Fig. 22) reveals Fabritius's careful study of his master's *The Night Watch*, completed in 1642. This proto-romantic self-portrait, in which the artist shows himself with long, tousled hair, open-necked shirt and working smock against a background of crumbling plasterwork, probably dates from shortly after *The Raising of Lazarus*. There was perhaps a sense in which the choice of this dress had a special significance for Fabritius. The Latin word *faber*, from which Carel's father had taken the cognomen Fabritius, means workman, and the painter's pose and dress in this portrait may have been intended as an allusion to his name. Compositionally, the most striking feature is the daring placing of the head so far down on the panel, giving a greater than usual emphasis to the part of the picture that is occupied by the peeling plaster wall, and allowing Fabritius to explore effects of texture and shadow. It is a measure of Carel's extraordinary imaginative gifts that he could dispense in this way with the conventional centrality of the sitter's head in a bust portrait. Fabritius was to move to Delft in 1650 but died four years later in the explosion of the municipal powder magazine in the town, a premature end to a remarkable career.

Fig. 22
CAREL FABRITIUS
The Raising of
Lazarus
c.1643-6. Oil on canvas,
210.5 x 140 cm. Warsaw,
Museum Narodowe

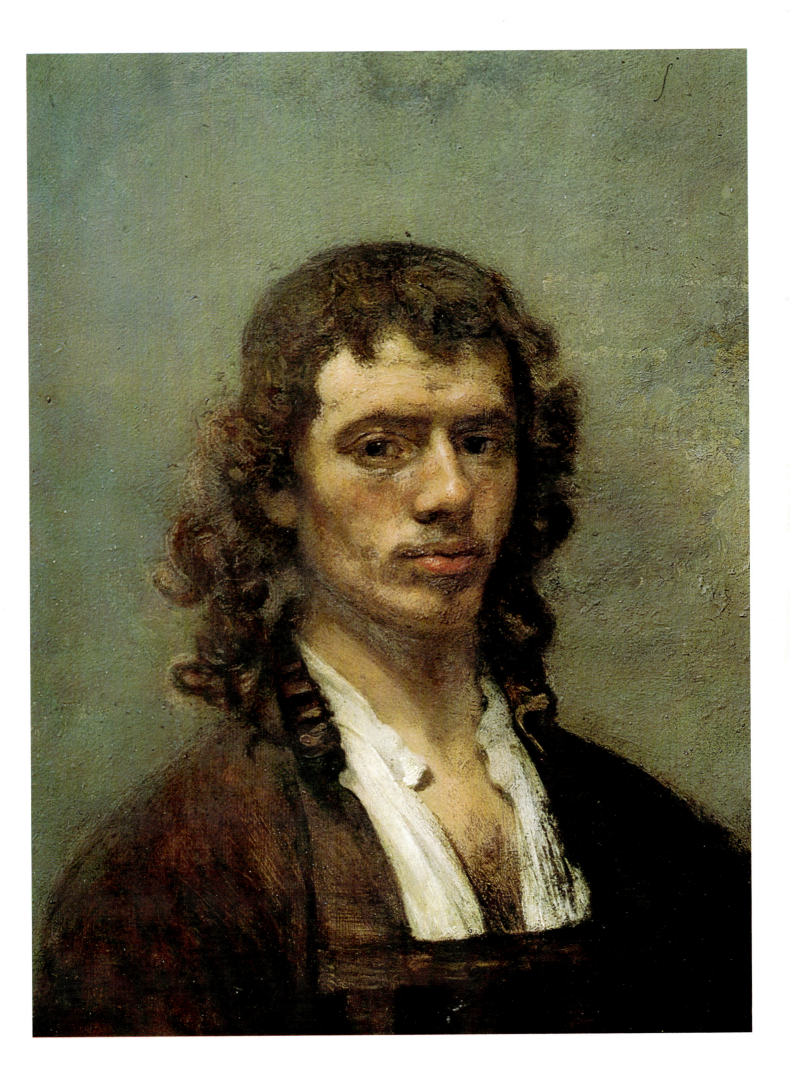

REMBRANDT VAN RIJN (1606 – 69)
Titus

1655. Oil on canvas, 77 x 63 cm. Rotterdam, Boymans-van Beuningen Museum

Titus van Rijn was born in 1641 and was the only child of Rembrandt and Saskia van Uylenburgh to survive into adulthood. Saskia died in the year after his birth and Titus was entrusted to the care of, firstly, Geertge Dircx and then Hendrickje Stoffels. After Rembrandt's bankruptcy, Hendrickje and Titus set up an art-dealing business in order to provide Rembrandt with protection against his creditors. Titus was trained by his father as a painter but hardly any trace of his artistic activities survive. After Hendrickje's death in 1663 Titus continued the art-dealing business. He married in 1668 but died in the same year, twelve months before his father.

Titus's features appear in a number of paintings by Rembrandt. He showed him in the habit of a monk (Rijksmuseum), seated reading (Vienna) and wearing an elegant costume, beret and gold chain (Fig. 23). Here he is seen as a schoolboy, seated at his desk, day-dreaming over his homework. In his right hand is his quill pen and his penholder and inkpot are in his left. The portrait is painted very freely – the boy's arms and his papers are indicated by no more than single brushstrokes – and on the desk can be seen the broad marks of Rembrandt's palette knife.

Fig. 23
REMBRANDT
VAN RIJN
Titus
c.1659. Oil on canvas,
67.5 x 55 cm. London,
Wallace Collection

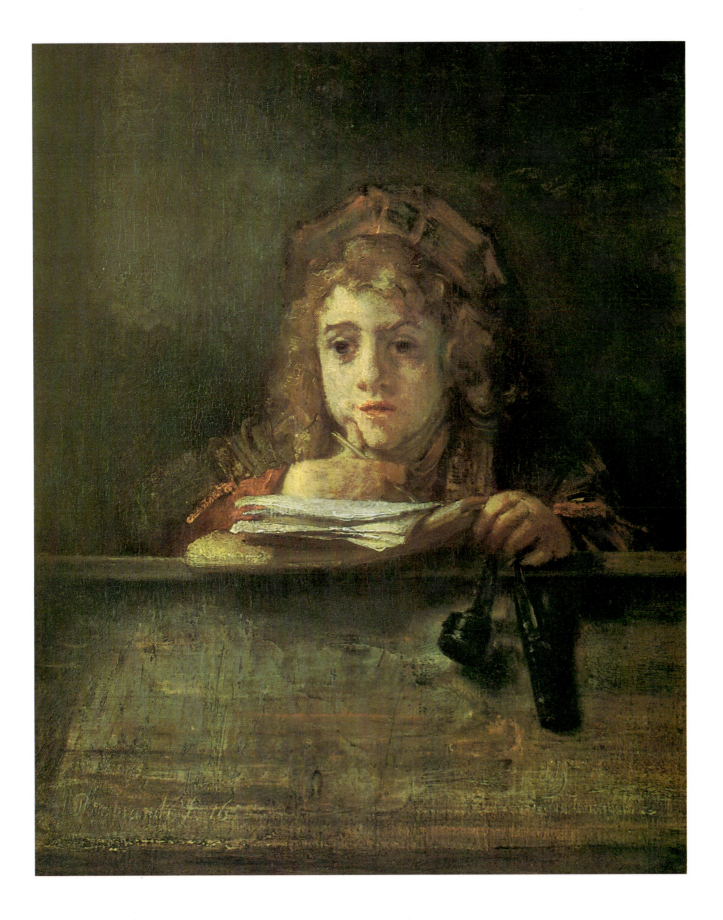

JAN STEEN (c.1625 – 79)
Skittle Players Outside an Inn

c.1660. Oil on wood, 33.5 x 27 cm. London, National Gallery

This idyllic landscape, with skittle players and figures seated on the grass outside *The White Swan* inn, is an unusual subject for Jan Steen, who is best known as a painter of rowdy domestic and tavern interiors (see Plate 17). Steen's work was unusual in its wide range of subject-matter in an age which encouraged specialization. Steen moved from town to town, and this apparent restlessness of temperament is reflected in the unevenness of his output. Often in financial difficulties, Steen was not above hack-work. At his best, however, as in this painting which probably dates from around 1660, Steen can rise to a level of technical skill and lyrical mood rarely achieved by even the greatest of Dutch painters.

The early seventeenth century saw the rapid urbanization of the north Netherlands: Amsterdam, Leiden, Haarlem and The Hague were among the cities which underwent a huge expansion. It was a popular recreation for the citizens of Holland's overcrowded towns to visit inns in the countryside. In *Les Delices de la Hollande*, published in Leiden in 1678, the French author Parival commented on the popularity of such outings: 'Whenever one goes here [into the countryside], one finds as many people as would be seen elsewhere in a public procession. All these excursions end up at one of the inns which are to be found everywhere These inns are always packed with visitors, and the confused murmur of many voices is like the sound in a city square. These are inexpensive pleasures which all, even the humblest labourer, can share.' As can be seen from Steen's painting, some enterprising landlords provided entertainment for their customers, in this case skittles, which was a popular game in the Netherlands.

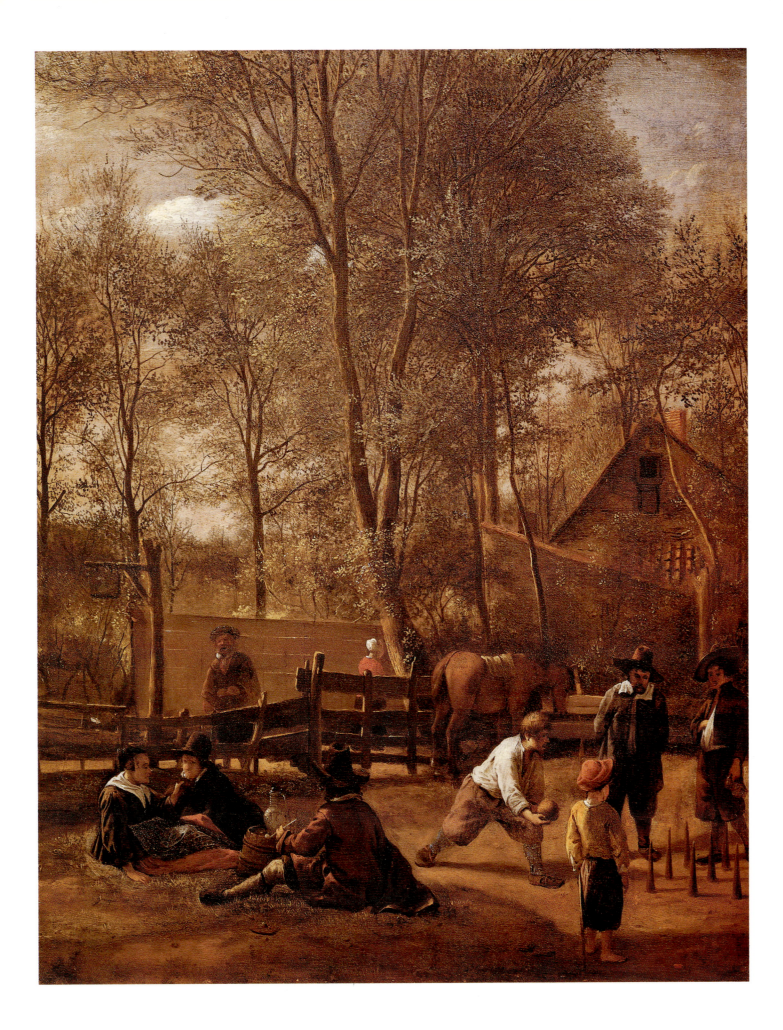

ISACK VAN OSTADE (1621 – 49)
A Winter Scene

c.1645. Oil on wood, 48.8 x 40 cm. London, National Gallery

Isack van Ostade was the short-lived younger brother of the painter of scenes from peasant life, Adriaen van Ostade (Fig. 24). They were both born, lived and worked in Haarlem, and Isack was a pupil of his brother who was eleven years his senior. Isack joined the guild in 1643. His earliest paintings – the first dated picture is from 1639 – are peasant interiors dependent on Adriaen's, but towards the end of his brief career he became more interested in outdoor scenes and produced a series of beautiful and original landscapes, often set in winter. This deliberately picturesque view, its low viewpoint serving to outline the wooden bridge against the sky, is one of his finest paintings. It is rich in its treatment of the details of peasant life, whose harsh aspects (as seen, for example, in the figure of the man labouring under his load of faggots) are relieved by the pleasure taken by the child in the anticipation of skating on the frozen river.

Fig. 24
ADRIAEN VAN
OSTADE
Interior of an Inn
c.1653. Pen and brown
ink, grey wash and
pencil on white paper,
16.7 x 17.5 cm. Windsor,
Royal Collection

REMBRANDT VAN RIJN (1606 – 69)
Jan Six

1654. Oil on canvas, 112 x 102 cm. Amsterdam, Six Collection

Jan Six, the subject of this remarkable portrait which is among the greatest painted by Rembrandt, was a friend and patron of the artist. Six (1618-1700) came from a noble Huguenot family which had fled to Amsterdam from Saint Omer in France at the end of the sixteenth century and amassed a fortune in the textile trade and from silk dyeing. Six was involved in the family business until he entered civic politics in Amsterdam, serving as burgomaster of the city in 1691. Passionately interested in the arts, particularly poetry, Six was a member of the so-called *Muiderkring* (Muiden circle) which gathered around Pieter Cornelisz. Hooft, and he published volumes of poetry and plays. He was an avid collector of works of art – Dutch and Italian masters, antique sculpture, engraved gems – and travelled widely, including an extended trip to Italy in 1640. Six owned a number of paintings by Rembrandt, among them the grisaille *Preaching of John the Baptist* (Berlin, Gemäldegalerie). Their relationship was, however, one of friendship rather than simply that of patron and artist. Rembrandt etched the title page for Six's tragedy *Medea* and made two drawings for his *Album Amicorum* in 1652.

This portrait, which is still owned by a direct descendant of the sitter, also Jan Six, captures the moment as Six pauses while putting on his gloves just before leaving the house. The hands, gloves and red cloak are painted very broadly in powerful strokes with a loaded brush, but the face, with its marvellous expression of momentary abstraction, has been heavily and precisely worked and reworked. It is one of Rembrandt's most sensitive and effective portraits and a remarkable tribute to the friendship between the two men. Three years later Rembrandt etched a portrait of Six standing at his window reading, with books and manuscripts in the foreground and a painting hanging on the wall (Fig. 2): it is a study of Six as poet and collector.

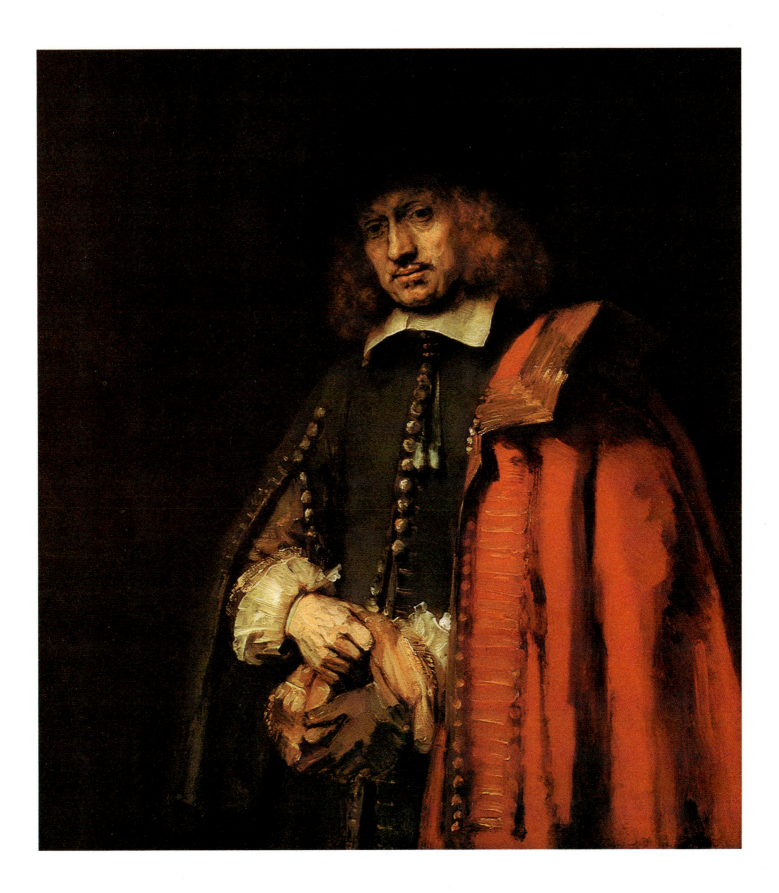

FRANS HALS (c.1580 – 1666)
Isabella Coymans (Detail)

c.1650 – 2. Oil on canvas, 116 x 86 cm. Paris, Private Collection

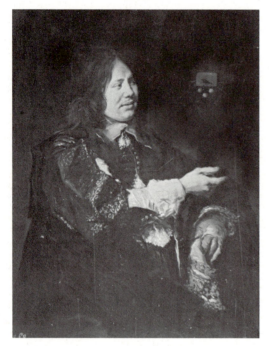

Fig. 25
FRANS HALS
Stephanus Geraerdts
c.1650-2. Oil on canvas,
115.4 x 87.5 cm. Musée
Royal des Beaux-Arts,
Antwerp

The pair of three-quarter length portraits of Stephanus Geraerdts (Fig. 25) and his wife Isabella Coymans is unique in Hals's *oeuvre*. Only here does he link two portraits so closely: Stephanus turns towards his wife (his portrait was to hang on the left) looking into her eyes and stretching out his right hand – from which he has removed his glove – to her. She turns her head towards him and extends her right hand which holds a rose. The couple had married in 1644 in Haarlem: at the time Geraerdts lived on the Keizersgracht in Amsterdam but he subsequently moved to Haarlem, which was Isabella's native town. The Coymans family was wealthy and distinguished: they were successful merchants and bankers. Isabella's uncles, Balthasar and Johannes, had commissioned Jacob van Campen to build them a large house in Amsterdam. Hals had also painted Isabella's parents, Josephus Coymans and Dorothea Berck in a pair of portraits in 1644 (today they are in the Wadsworth Athenaeum, Hartford, Connecticut and the Walters Art Gallery, Baltimore, Maryland). In the following year Hals painted a portrait of the twenty-six-year-old Willem Coenraetsz. Coymans, another member of the family, in a rakish hat and gold embroidered jacket (in the National Gallery of Art, Washington). It was presumably the success of these portraits that led to the important commission for the accomplished and animated portraits of Geraerdts and his wife.

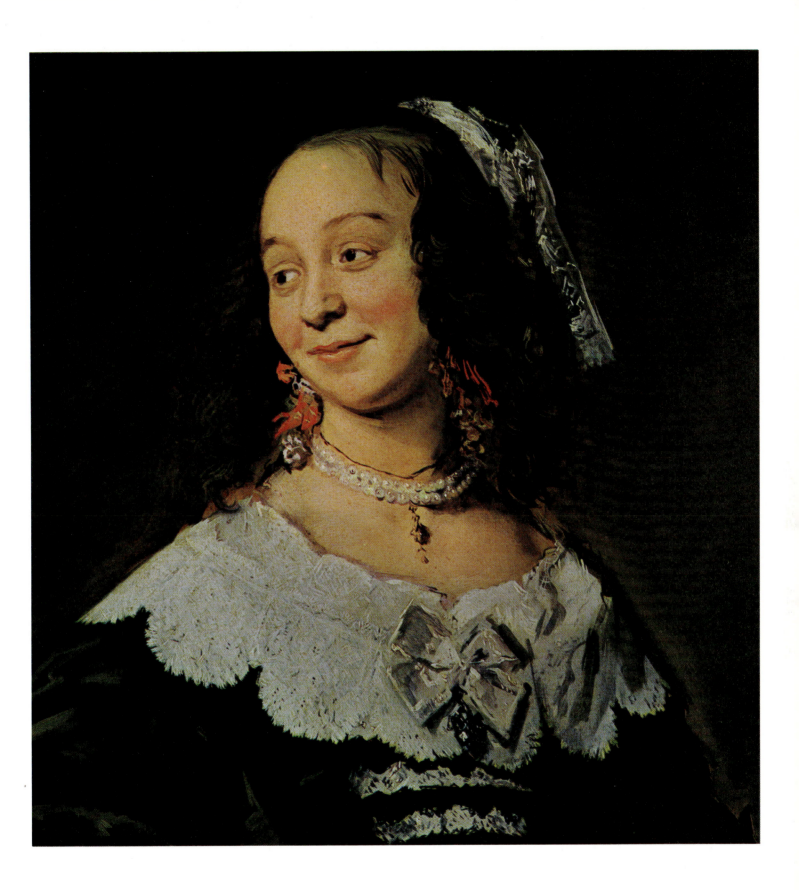

REMBRANDT VAN RIJN (1606 – 69)
The Polish Rider

c.1655. Oil on canvas, 114.9 x 135 cm. New York, Frick Collection

This portrait of a young man on horseback was discovered by the great Rembrandt scholar and Director of the Mauritshuis, Abraham Bredius, in the castle at Dzikow in Galicia in 1897. In his notebook he describes the intense excitement with which he first viewed the painting at the end of a long day's travelling. Bredius always considered it to be his greatest discovery: it was shown in Amsterdam at the Rembrandt exhibition in the following year and in 1910 was sold to the steel magnate Henry Frick for the enormous sum of £60,000. Since that time it has been one of the greatest treasures of the Frick Collection. The precise subject has been a matter of debate. It has been interpreted both as an allegorical portrait of the Christian knight defending Christendom against the infidel and as a portrait of one of the young Polish aristocrats who studied at Dutch universities in the seventeenth century. Certainly the *joupane* (a three-quarter length coat buttoned from neck to waist), cap, tight-fitting red trousers and calf-length boots, and the swords, bows and arrows and war hammer, are more or less consistent with his being a Polish (or even Hungarian) horseman. The horse itself has a flying *kutaz*, possibly made from horsehair, attached to the bridle. The background is very broadly painted in dark tones and is difficult to read but behind the figure is a hill surmounted by a large circular, domed building.

The problems surrounding the painting have been further deepened by the recent rejection of the attribution to Rembrandt by a senior member of the Rembrandt Research Project: an alternative attribution to Willem Drost has been proposed. There is nothing in the known *oeuvre* of Drost which possesses the imaginative power and bravura brushwork of *The Polish Rider* and the case for the reattribution of what is admittedly an unusual painting in Rembrandt's work must for the time being be considered unproven.

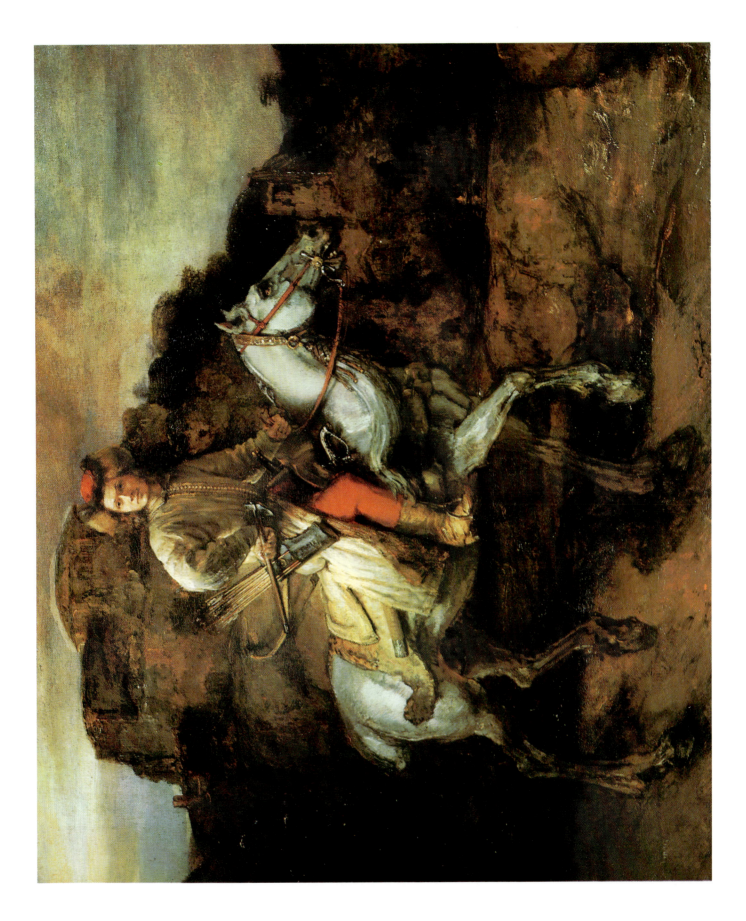

REMBRANDT VAN RIJN (1606 – 69)
Jacob Blessing the Children of Joseph

1656. Oil on canvas, 175.5 x 210.5 cm. Kassel, Gemäldegalerie

Although he was an infinitely skilful and perceptive portraitist, Rembrandt always thought of himself in the first place as a history painter, that is, a painter of scenes from the Bible, classical history and mythology. This painting of 1656 is one of Rembrandt's greatest achievements as a history painter. The subject is taken from the book of Genesis, chapter 48. The dying patriarch Jacob is shown blessing his grandsons Ephraim and Manasseh. Their father Joseph and his wife Asenath stand behind the children. Rather than blessing the eldest son, the dark Manasseh, with his right hand, Jacob gave his first blessing to the younger, the fair-haired Ephraim. Joseph thought that his father had made a mistake but Jacob replied 'I know it, my son, I know it; he also shall become a prophet, and he also shall be great; but truly his younger brother shall be greater than he, and his seed shall become a multitude of nations.' It was later claimed by the early fathers of the church, notably Ambrose and Augustine, that Ephraim was the ancestor of the Christians and Manasseh of the Jews. In Rembrandt's version Jacob blesses Ephraim but there is no sign of Joseph's questioning of his father – indeed he steadies his father's hand – and the presence of Asenath is not mentioned in the Biblical account. She is mentioned only once in the Bible (Genesis chapter 41, verse 45) but Rembrandt makes her a major figure of great dignity, balancing the two men on the left. She was Egyptian and wears a headdress of a late medieval Burgundian type which Rembrandt must have considered Egyptian in origin. The prime focus of the painting is, however, on the tender gesture of the aged patriarch as he blesses Ephraim, and Joseph's outstretched hand and kind smile as he assists his father (Fig. 10). The central scene is broadly painted in delicate yellows, browns and reds with remarkable economy and precision. Rembrandt creates a mood which is both intimate and sacred, tender and solemn.

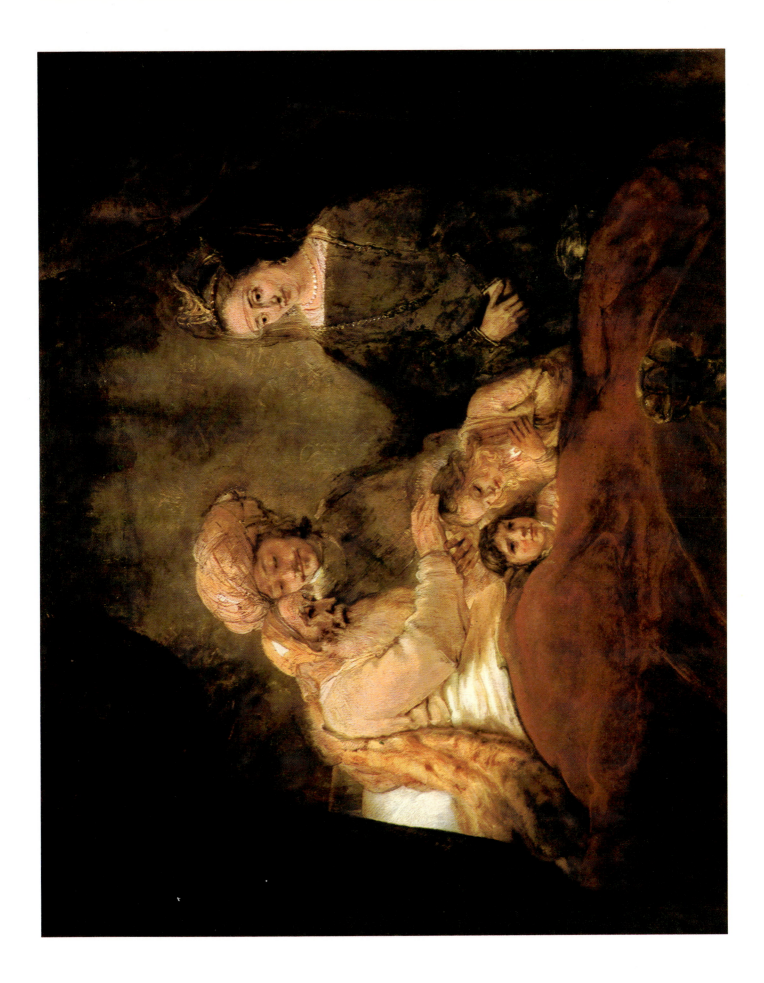

WILLEM VAN DE VELDE
THE YOUNGER (1633 – 1707)
The Cannon Shot

c.1670. Oil on canvas, 78.5 x 67 cm. Amsterdam, Rijksmuseum

Willem van der Velde the Younger was first trained in the Amsterdam studio of his father, Willem the Elder, who was a distinguished ship 'portraitist'. Willem the Elder specialized in *penschilderijen*, pen drawings of ships on panel or canvas made in a manner similar to engravings (Fig. 26). Subsequently his son completed his training with Simon de Vlieger, the marine painter, in Weesp. Willem the Younger then joined his father in his studio and continued to live and work in Amsterdam until 1672. In that year, the so-called *rampjaar*, the French invasion of the Netherlands caused such economic chaos that painters found it difficult to earn a living. (Vermeer was also among the many Dutch artists who experienced financial hardship at this time.) Both father and son moved to England and in 1674 were taken into the service of Charles II: the warrant of appointment states that each is to be paid a hundred pounds a year, in addition to payments for their pictures, the father for 'taking and making of Draughts of seafights' and the son for 'putting the said Draughts into colours'. One important early royal commission was for designs for tapestries commemorating the Battle of Solebay. They lived for the rest of their lives in England, working in their studio at the Queen's House, Greenwich, for Charles II, James II and members of their courts.

This study of a man-of-war firing a cannon – as a signal, rather than in battle – was painted in about 1670, shortly before van de Velde left Amsterdam for London. Rather than a seascape, it is essentially a 'portrait' of the ship. In his later years Willem the Younger employed numerous assistants and the quality of his work declined, but this picture is entirely from his own hand and displays the remarkable atmospheric effects of which he was capable.

Fig. 26
**WILLEM VAN
DE VELDE
THE ELDER**
The Battle of
Scheveningen,
10 August 1653
1653. Grisaille on wood,
113.3 x 155.8 cm.
Greenwich, National
Maritime Museum

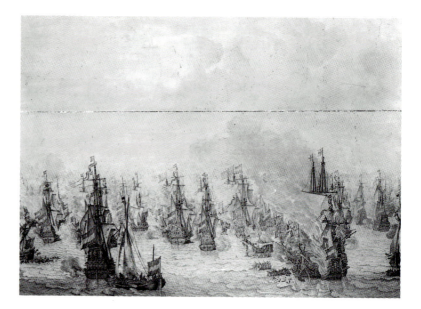

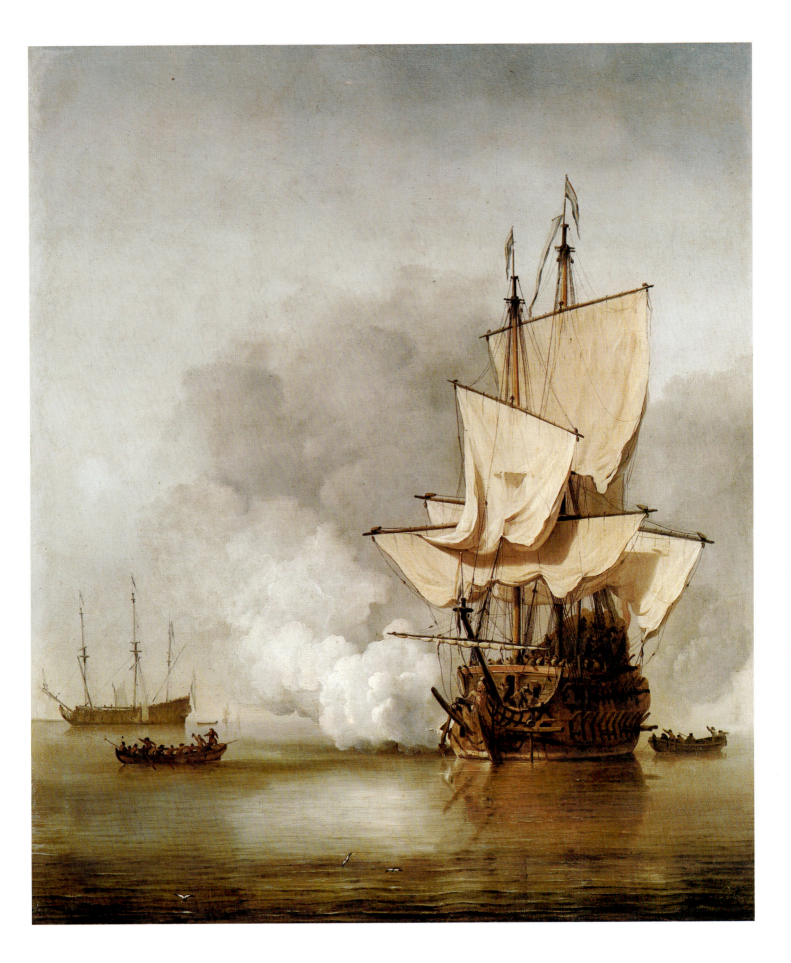

WILLEM KALF (1619 – 93)
Still Life with Nautilus Cup

1662. Oil on canvas, 79 x 67 cm. Madrid, Thyssen-Bornemisza Collection

One of the most characteristic types of painting in Holland in the seventeenth century was still life which was brought to a higher level of refinement there than anywhere else in Europe. Some still lifes have symbolic meanings – the vanity of earthly wealth – but others, including those of the greatest practitioner of this genre, Willem Kalf, seem to be simply *pronkstilleven*, lavish displays of ceramics, glassware, gold and silver vessels as well as exotic food. They reflect a new willingness of rich Dutchmen to parade their possessions, an attitude which would have been frowned upon by an earlier, more puritanical generation.

Kalf was born in Rotterdam and probably trained in the studio of Francois Ryçkhals in Middelburg, a town with a long established tradition of still-life painting. Subsequently he lived for some years in Paris where he met Flemish still-life artists, whose painterly style softened the linearity of Kalf's earliest manner. Kalf returned to Rotterdam but settled in Amsterdam in 1653 with his wife Cornelia Pluvier, a distinguished glass-engraver, poetess and musician. In the following year Kalf was praised by the poet Jan Vos as one of the city's leading painters: he was much sought after by prosperous citizens anxious to record their treasures. This particular painting includes a richly decorated nautilus cup and a Wan-Li bowl, which were no doubt prized possessions of the unknown Amsterdammer who commissioned the still life.

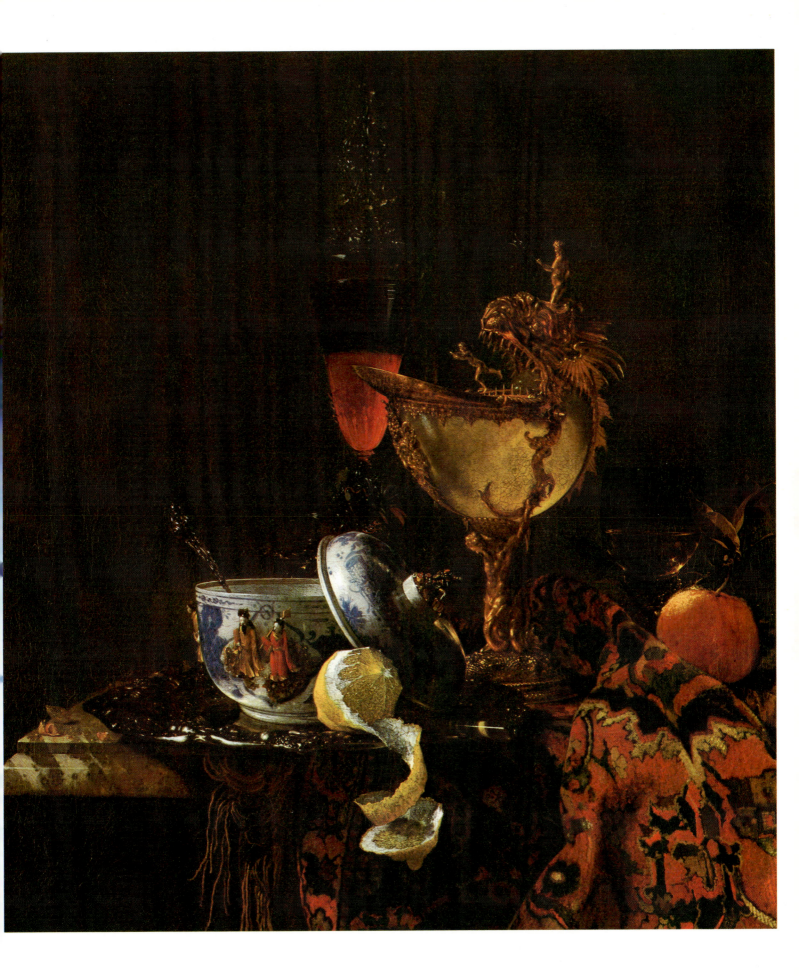

PHILIPS KONINCK (1619 – 88)
An Extensive Landscape with a Road by a Ruin

1655. Oil on canvas, 137.4 x 167.3 cm. London, National Gallery

Among his contemporaries, Philips Koninck was known as a figure painter, specializing in portraits as well as in genre and religious scenes, rather than as a landscapist as he is known today. He was born in Amsterdam, the son of a successful goldsmith, and trained in the studio of his brother, Jacob, who worked in Rotterdam. Subsequently he returned to Amsterdam, where he lived for the rest of his life. Koninck was a wealthy man, owning a company which operated *trekschuiten* (horse-drawn passenger barges) between Rotterdam and Amsterdam. He seems to have been a friend rather than a pupil of Rembrandt but he was certainly influenced by him in his manner of painting (and drawing) biblical subjects.

Koninck's landscapes are characterized by a high viewpoint and a sky which occupies at least half of the picture space. They are cloudscapes as much as extensive landscapes. He emphasizes the flatness of Holland, a more realistic approach than, for example, that of Aelbert Cuyp (Plate 34), who attempts to make his landscapes more varied by the inclusion of hills and mountains taken from his imagination rather than from his observation of the Dutch countryside. The landscape with a high sky was particularly in favour in the 1650s and 1660s, not just in the work of Koninck, but also in that of Jacob van Ruisdael (Plate 31) and also in the etched landscapes of Rembrandt (Fig. 27).

This painting of 1655 is an outstanding example of Koninck's landscape art. The colours, which in some of his canvases have sunk into uniform browns and greys with the passage of time, are particularly vivid and the painting is remarkably well preserved.

Fig. 27
REMBRANDT
VAN RIJN
Cottages beside a
Canal, with a Church
and Sailing Boat
c.1642–3. Etching,
14 x 20.7 cm. London,
British Museum

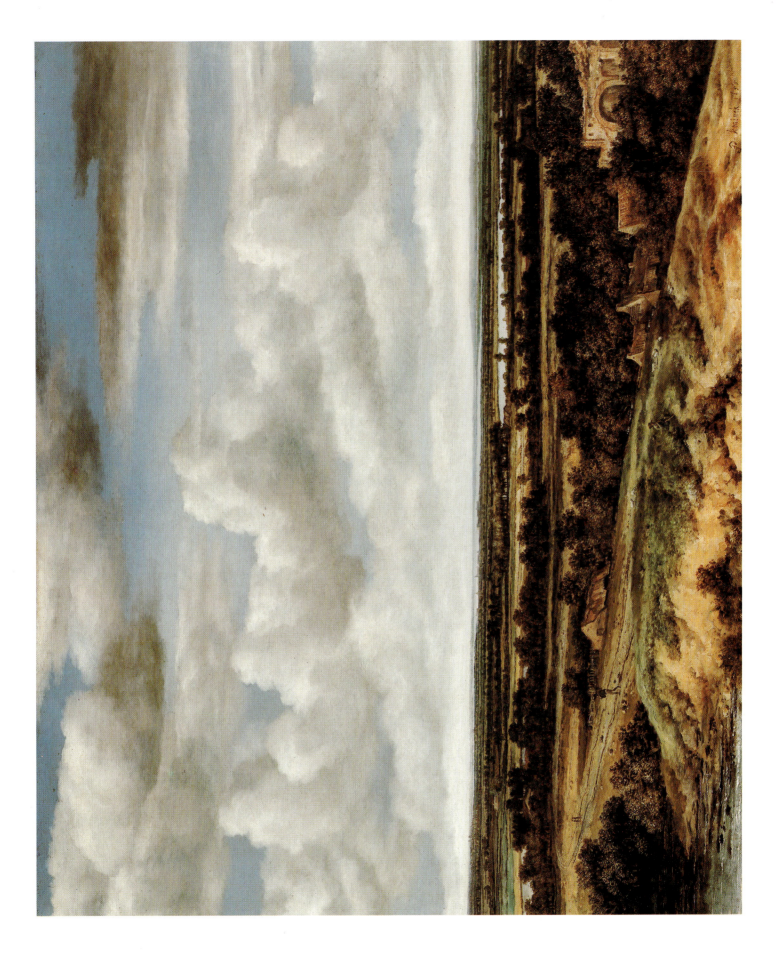

JACOB VAN RUISDAEL (c.1628 – 82)
A Landscape with a Ruined Castle and a Church

c.1665-70. Oil on canvas, 109 x 146 cm. London, National Gallery

In the late 1660s, perhaps inspired by the example of Philips Koninck (Plate 30), Jacob van Ruisdael painted a number of extensive landscapes, of which this is a particularly fine example. Like Koninck, he adopts a high viewpoint, devoting more than half the canvas to a cloud-filled sky. It has been suggested that the church in the centre is that of St Agatha at Beverwijk, about seven miles north of Haarlem, where Ruisdael lived and worked. The tower of that church, however, was different and in any case it is unlikely that Ruisdael was attempting topographical accuracy. The painting was no doubt based on drawings made in the vicinity of Haarlem which Ruisdael then took back to his studio and transformed into an imaginative landscape. There are four other landscapes by Ruisdael which show the same view or part of the same view with small differences of detail. The figure of a man standing among the ruins in the right foreground and the swans in the moat are by Ruisdael himself, but the two peasants and their animals on the left foreground are by another artist, Adriaen van de Velde, who often collaborated with Ruisdael. The picture has been convincingly dated to the late 1660s: it cannot have been painted later than January 1672, the date of Adriaen van de Velde's death.

CASPAR NETSCHER (1639 – 84)
The Lace-Maker

1662. Oil on canvas, 33 x 27 cm. London, Wallace Collection

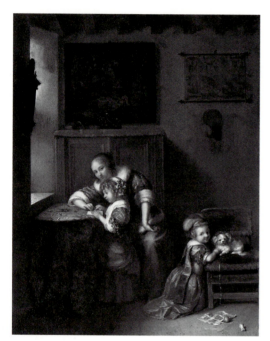

Fig. 28
CASPAR
NETSCHER
A Lady Teaching
a Child to Read
c.1675. Oil on wood,
45.1 x 37 cm. London,
National Gallery

Caspar Netscher is said to have been born in Prague but moved as a child to Arnhem, where he was a pupil of the local painter Herman Coster before entering the studio of Gerard ter Borch in Deventer. (The central figure in ter Borch's *An Officer Dictating a Letter* – Fig. 29 – has been identified as Netscher.) He set out for Italy but only got as far as Bordeaux where he stayed for several years before returning to Holland in 1662 and settling in The Hague. He established a great contemporary reputation, particularly as a portrait painter, and is said to have been invited to England by Charles II. He declined to go, although he painted many English and French sitters in The Hague. His portraits, most of which are on a small scale, were strongly influenced in style by van Dyck and his followers.

In his early years, before devoting himself exclusively to portraiture, Netscher painted small-scale genre paintings and also some religious and classical subjects: the earlier ones are related stylistically to the work of ter Borch and Metsu, the later ones to Frans van Mieris the Elder (see Plate 48). This painting was cleaned in 1990 and the correct date of 1662 revealed. It stands, therefore, at the very beginning of Netscher's career as an independent artist in The Hague. It is one of his most successful works, remarkable for the modesty of its subject, its richness of colour and firmness of modelling. It is an image which celebrates the effective performance of quiet domestic duties. The landscape print pinned to the wall (at the bottom of which can be seen the artist's signature and the picture's date) shows how such works were displayed in households which were not prosperous enough to afford paintings.

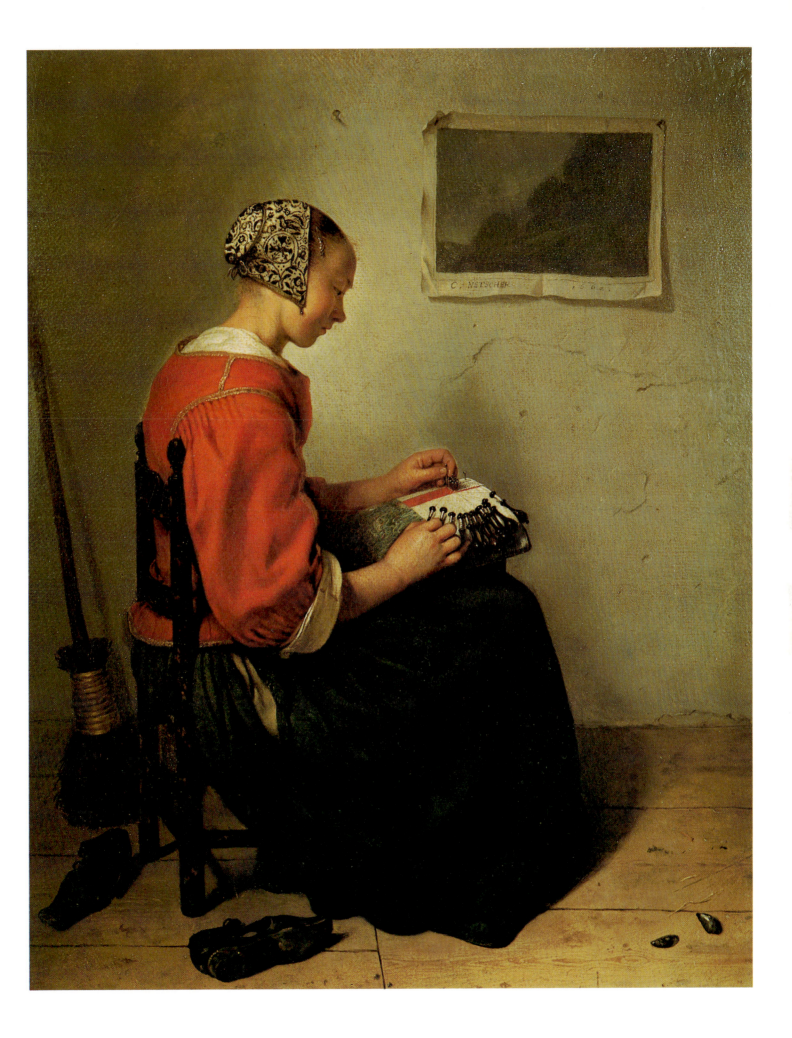

GERARD TER BORCH (1617 – 81)
A Boy Ridding his Dog of Fleas

c.1665. Oil on canvas, 35 x 27 cm. Munich, Bayerische Staatsgemäldesammlungen

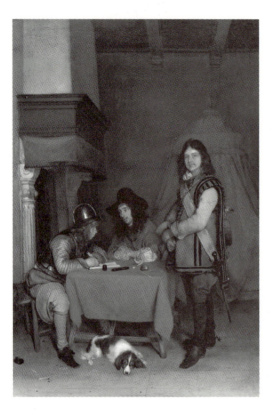

Fig. 29
GERARD
TER BORCH
An Officer Dictating
a Letter
c.1655. Oil on canvas,
74.5 x 51 cm. London,
National Gallery

With Pieter de Hooch and Johannes Vermeer, Gerard ter Borch is one of the most outstanding of Dutch genre painters. Their paintings are based on close observation of their contemporaries and their surroundings, and yet elements from everyday life are often combined to suggest a particular mood, create an intriguing situation or point a moral.

Ter Borch, the son of a painter, was born in Zwolle and trained there in the studio of his father and also in the Haarlem workshop of the landscape painter Pieter Molijn. In his youth he travelled widely in Europe – to Germany, Italy, England, France and Spain. By 1654 he had settled in Deventer in his native province of Overijssel, where he achieved great professional success. He also became one of the town's regent class, serving as a councillor and painting a group portrait of his fellow regents. In the genre scenes of his early years ter Borch depicted the life of soldiers (Fig. 29) but after settling in Deventer his paintings often showed elegant interiors in which small groups of figures talk, drink and make music. In this painting ter Borch shows a humbler setting and a mundane subject and yet he treats with the same delicacy and refinement the depiction of the differing textures of fur, hair, wood and felt. As with the painting of the lace-maker by Netscher (Plate 32), the painting gives an almost monumental quality to an everyday situation.

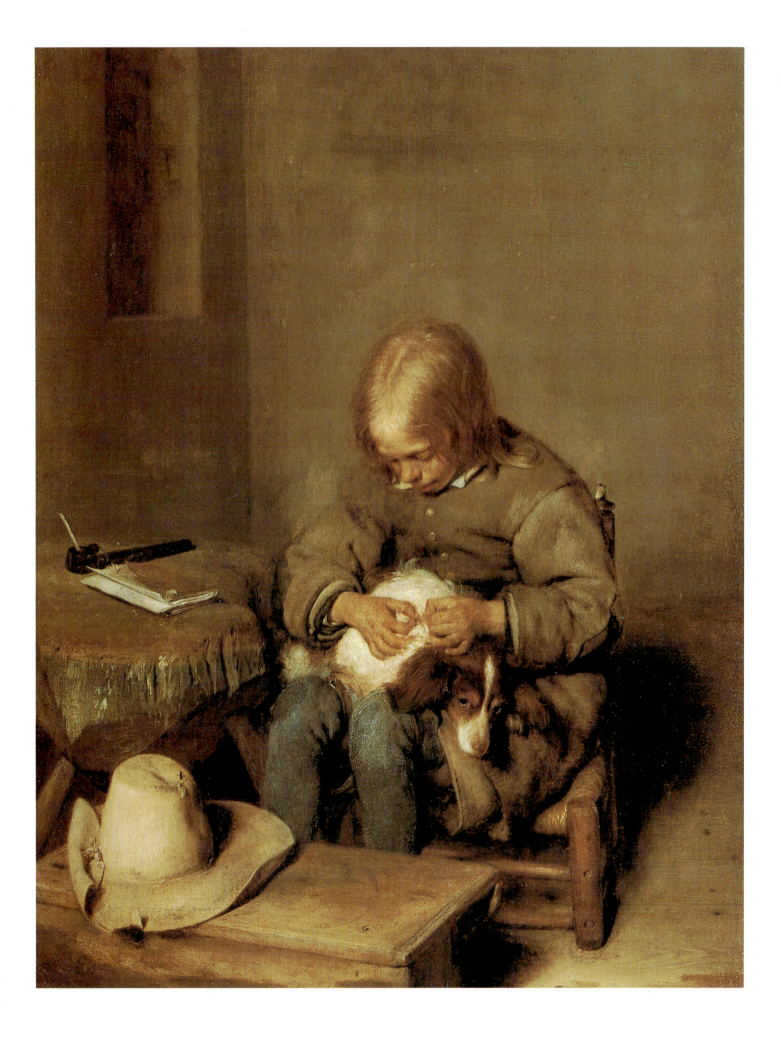

AELBERT CUYP (1620 -91)
View of Dordrecht

c.1655. Oil on canvas, 97.8 x 137.8 cm. London, Kenwood House, Iveagh Bequest

Aelbert Cuyp lived and worked in Dordrecht which, although a small provincial town, had a flourishing local school of painting. Nicolaes Maes, Samuel van Hoogstraten and Aert de Gelder also worked in the town.

Cuyp's early landscape style is close both in its grey-green palette and sketchy technique to that of Jan van Goyen but in the early 1640s his style was transformed by his encounter with the landscape style which the Utrecht artist Jan Both had developed during his stay in Italy (Fig. 5). Cuyp never visited Italy but he developed an idiosyncratic version of Both's style. He bathed his very Dutch landscapes in a golden Italian sunlight which sparkles on the water and warms the stones of the buildings. Having adopted and refined his version of the Italianate landscape style, Cuyp practised it for many years of a successful career, which he ended as a member of the regent class of Dordrecht and an elder of the Reformed Church, the owner of a fine town house and an extensive country estate. Because his style does not develop significantly his paintings are difficult to date but this view of his native town from the River Maas was probably painted in about 1655. The outline of the city is dominated by the profiles of the Groothooftspoort on the left and the squat tower of the Grote Kerk, a familiar landmark in Cuyp's many views of his home town, to the right.

JAN VAN DE CAPPELLE (1626 – 79)
A Shipping Scene with a Dutch Yacht Firing a Salute

1650. Oil on canvas, 85.5 x 114.5 cm. London, National Gallery

Jan van de Cappelle is today considered to be one of the greatest of Dutch marine painters. According to a contemporary he was self-taught but he clearly took as his models Simon de Vlieger and Jan Porcellis, works by both of whom were in his own large collection of paintings and drawings. Porcellis had been the first marine painter to break with the dominant Mannerist style of Hendrick Vroom, in whose paintings elaborately described two-dimensional ships were tossed on the top of bright green waves. Porcellis adopted a very restricted grey, black and white palette to paint realistic scenes of storms at sea, a style which De Vlieger developed in the direction of greater naturalism by extending the range of the palette and the ambition of the compositions.

Van de Cappelle further extended the possibilities of this naturalistic style. He employs a low horizon, as Ruisdael and Koninck did in their landscapes, and consequently the sky assumes almost as great a significance as the scene beneath it. Although carefully composed, van de Cappelle's paintings seem to give the impression of a scene glimpsed suddenly by cutting off parts of ships on one or both sides of the composition – as here on the left. In this painting of 1650 the focus of the scene is the States' yacht in the centre with the Dutch flag and the coat of arms on her stern: she is firing a salute and a trumpeter on board is sounding. In the right foreground is a row-barge also flying the Dutch flag and with a distinguished man in the stern with the Dutch colours in his hat. It is this visitor who has presumably just left the yacht. Van de Cappelle was especially skilful at representing the cluster of masts and sails, and the reflections of the ships in the unruffled surface of the water.

Van de Cappelle, who lived and worked in Amsterdam, produced relatively few paintings. His family owned a dye-works, from which he derived his considerable wealth, and he amassed a fascinating collection of works by other artists.

GERARD TER BORCH (1617 – 81)
A Dancing Couple

c.1660. Oil on canvas, 76 x 68 cm. Polesden Lacey, The National Trust

This is one of an outstanding group of interior scenes with figures painted by ter Borch in Deventer in the years around 1660. He paints young men and women in elegant rooms, talking, dancing, drinking, making music and flirting. In addition to his skill in setting the scene, ter Borch possesses a remarkable technical gift, especially in the description of texture. No Dutch artist rendered satin more effectively than ter Borch nor was able to differentiate better in the medium of oil paint between the textures of a leather jerkin, a gleaming breastplate, a table carpet, a wooden lute and a brass candelabra.

In 1658 ter Borch was in Delft where he witnessed a document with the young Vermeer. This recently discovered evidence of a direct contact between the two artists confirms what has long been suggested: that the simplicity and restraint of ter Borch's style exercised an important influence on the Delft painter.

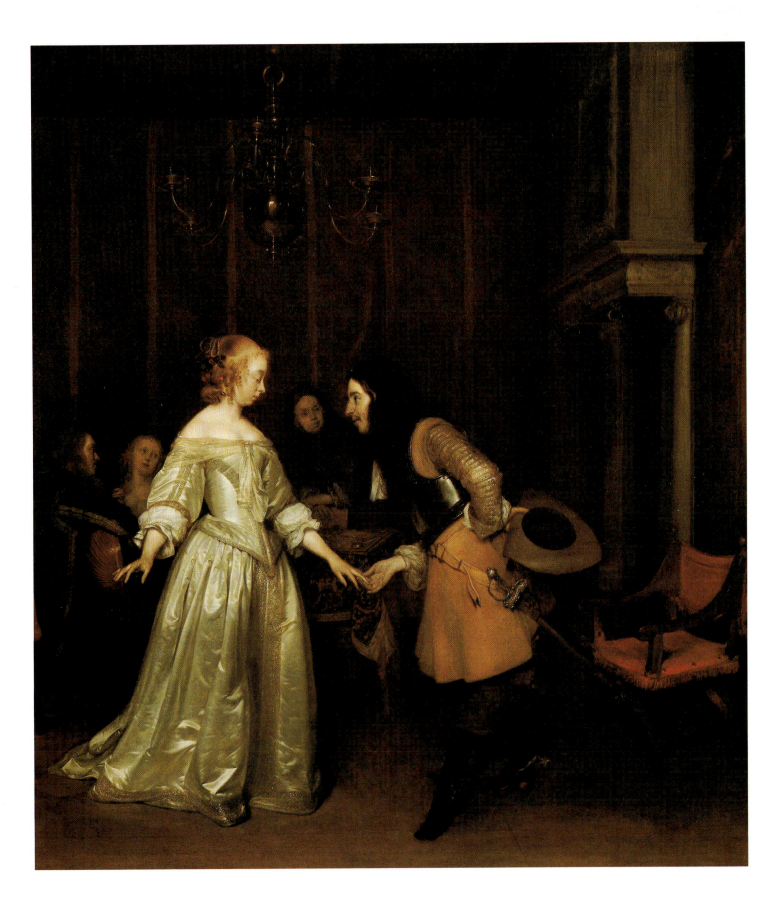

JAN STEEN (c.1625 – 79)
The Morning Toilet

1663. Oil on wood, 64.7 x 53 cm. London, Royal Collection

The girl is shown in a state of undress, provocatively pulling on her stocking and looking directly – and invitingly – at the spectator. The erotic character of this delicately painted and boldly coloured panel cannot be doubted. It has been argued that she is probably a prostitute – above the arch is Cupid and beside her bed a jewel-case – and yet the scene, framed in an archway, gives few real clues as to her status. We may, in fact, simply be glimpsing a desirable young woman at her toilet. The lute and the music book in the archway (as well as Cupid) associate the scene with the pleasures of love, while the skull wreathed in vine leaves reminds us that such pleasures are fleeting. The chamber pot is a characteristically realistic and down-to-earth element, while the archway with its Corinthian columns and swags of flowers frames this all-too-human scene in a mock grandiose manner. Today we may admire not just the illusionism, the amusing conceit of the subject but also the remarkable skill with which Steen described the rush-carpet, the canopied bed, the tiled floor and all the other details which go to make up this rich and intricate composition.

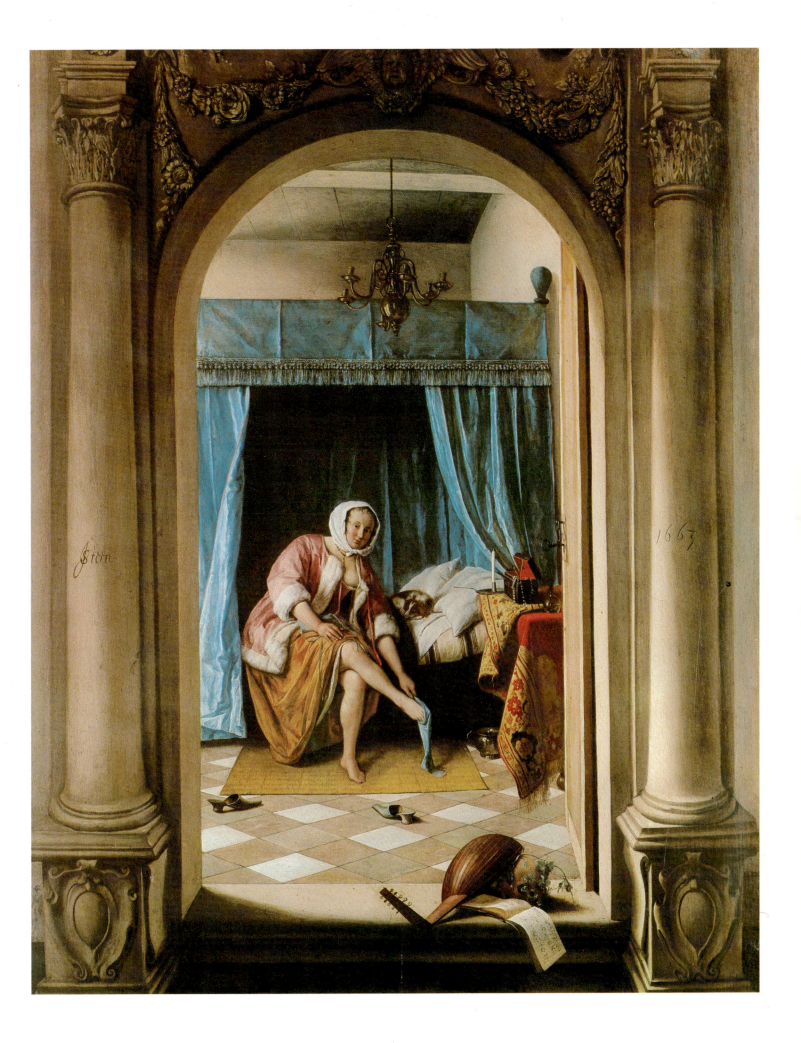

EMANUEL DE WITTE (c.1616 – 92)
Interior of a Protestant Gothic Church

1668. Oil on canvas, 78.5 x 11.5 cm. Rotterdam, Boymans-van Beuningen Museum

Emanuel de Witte was born and trained in Alkmaar but had come to Delft by 1641 and joined the painters' guild there in the following year. He remained in Delft for ten years but it was only at the end of his stay in the town, around 1650, that he began to paint the church interiors which form the greater part of his work. With his two Delft contemporaries, Gerard Houckgeest and Hendrick van Vliet, he developed this new type of subject-matter for painting. They painted 'portraits' of the churches of Delft (and elsewhere), although they allowed themselves some leeway in the arrangement of individual architectural and other elements for compositional purposes. The tombs of the heroes of the Republic, notably those of Piet Hein in the Old Church and William the Silent in the New Church, were chosen as a patriotic focus for some of the compositions. Bright daylight, passing through the clear glass of the windows, illuminates the whitewashed interiors, with their tiled floors, memorial tablets and heraldic banners (see Fig. 6). Figures are glimpsed between the columns and in front of the tombs, not all of them treating their surroundings with appropriate reverence. In this painting the gravedigger pauses to gossip, while a man on the left sleeps, watched over by his dog.

Houckgeest seems to have been the innovator in this group of artists but De Witte, the greatest painter of the three, softened the harsh linearity of Houckgeest's style. De Witte, unlike Houckgeest and Van Vliet, was a sensitive colourist, offsetting the severe black and white of the church interiors with patches of bright reds, yellows and greens. By January 1652 De Witte had moved to Amsterdam where he continued to specialize in church interiors.

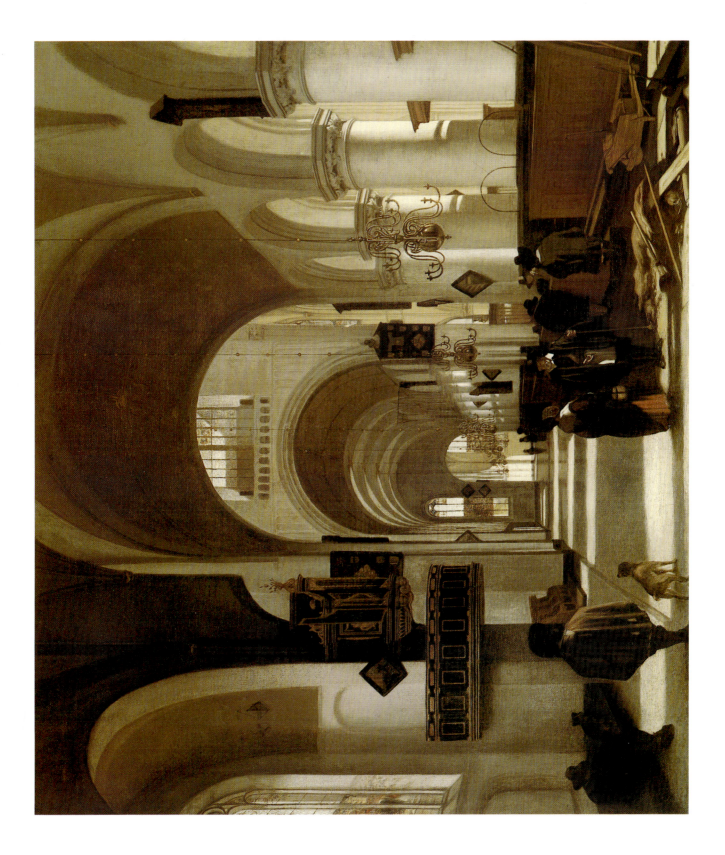

PIETER DE HOOCH (1629 – 1684)
At the Linen Closet

1663. Oil on canvas, 72 x 77.5 cm. Amsterdam, Rijksmuseum

Pieter de Hooch had moved from Delft to Amsterdam by 15 April 1661, when one of his daughters was baptized in the Westerkerk. In his Amsterdam years his domestic interiors became richer and his compositions more complex. His technique becomes progressively cruder and his late paintings often contain clumsy figure drawings and a coarse palette. In a painting such as this one, however, from his early years in Amsterdam, De Hooch applies the delicate technique of his Delft scenes (see Plate 19) to grander Amsterdam interiors. Here a classical statuette stands over the pilastered doorway and the woman and her maid take clean linen from an ornate *kast* inlaid with ebony and surmounted by porcelain. In the background a child playfully wields a *kolf* stick. Paintings such as these accurately show the details of Dutch interiors of the period and it is interesting to see a portrait in an elaborately carved gilt frame hanging alongside a landscape in a simple ebony frame. Through the open door, we can glimpse the buildings on the other side of the canal.

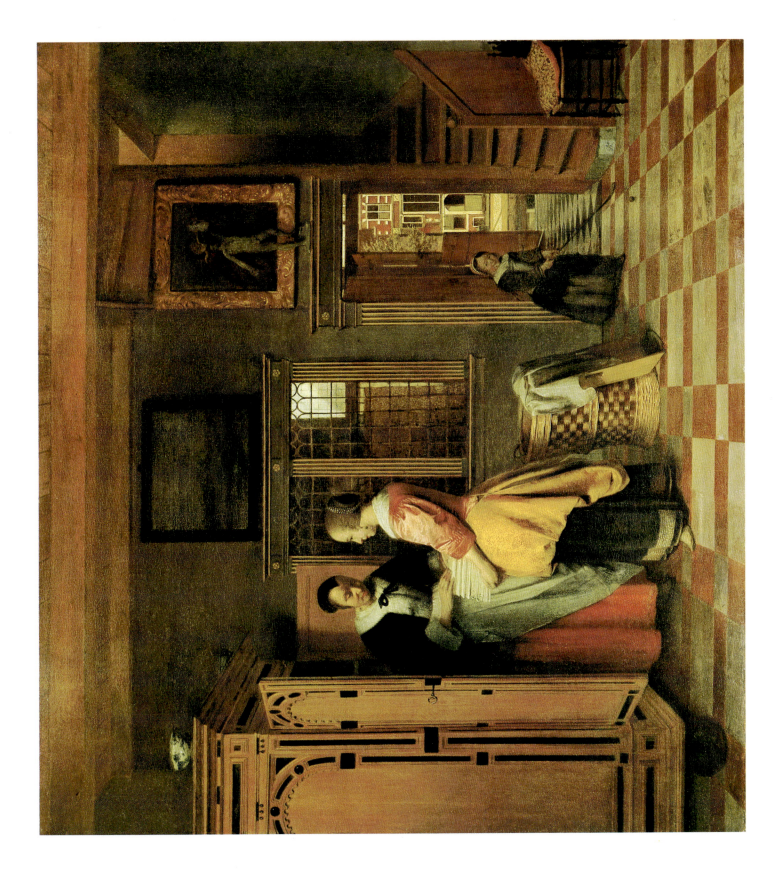

FRANS HALS (c.1580 – 1666)
Regents of the Old Men's Alms House

1664. Oil on canvas, 172.5 x 256 cm. Haarlem, Frans Halsmuseum

The two great portrait groups of the Regents and Regentesses of the Old Men's Alms House in Haarlem, which today both hang in the Frans Halsmuseum in the town, are traditionally said to have been painted in 1664. The five Regents portrayed by Hals held their offices from 1662 to 1665 and it was very usual to mark the end of their term of office by commissioning a group portrait of this kind. They are Jonas de Jong, Mattheus Everswijn, Dr Cornelis Westerloo, Daniel Deinoot and Johannes Walles. As no documented portraits of these men survive, it has proved impossible to link the names to individual portraits. There is an old legend that Hals, reduced to poverty in his last years and an inmate of the Alms House, took his revenge on the Regents by depicting them in unflattering fashion. In fact, although he was certainly poor, he was never in the Alms House and the bold, free and animated style of the group is also evident in his other portraits of this period. It has been convincingly argued that the unusual expression on the face of the Regent who is seated on the right is the consequence of partial facial paralysis rather than – as the legend has it – drunkeness. Such candour is characteristic of Hals who felt no need to disguise the Regent's affliction. The standing figure, without a hat, is the servant of the Regents.

These two group portraits, painted at the very end of Hals's long career, display the remarkable shorthand that he (and other great painters in old age) discovered. No brushstroke is out of place or extraneous: there is no unimportant description of detail but a concentration upon essentials, the evocation of character in a few unerringly placed brushstrokes.

Fig. 30
FRANS HALS
Regentesses of the
Old Men's Alms
House, Haarlem
1664. Oil on canvas, 170.5
x 249.5 cm. Haarlem,
Frans Hals museum

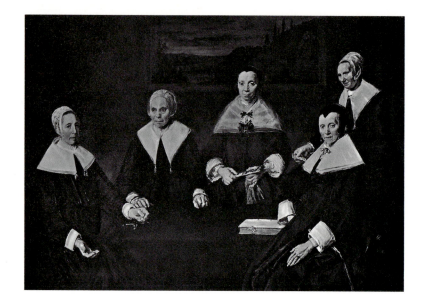

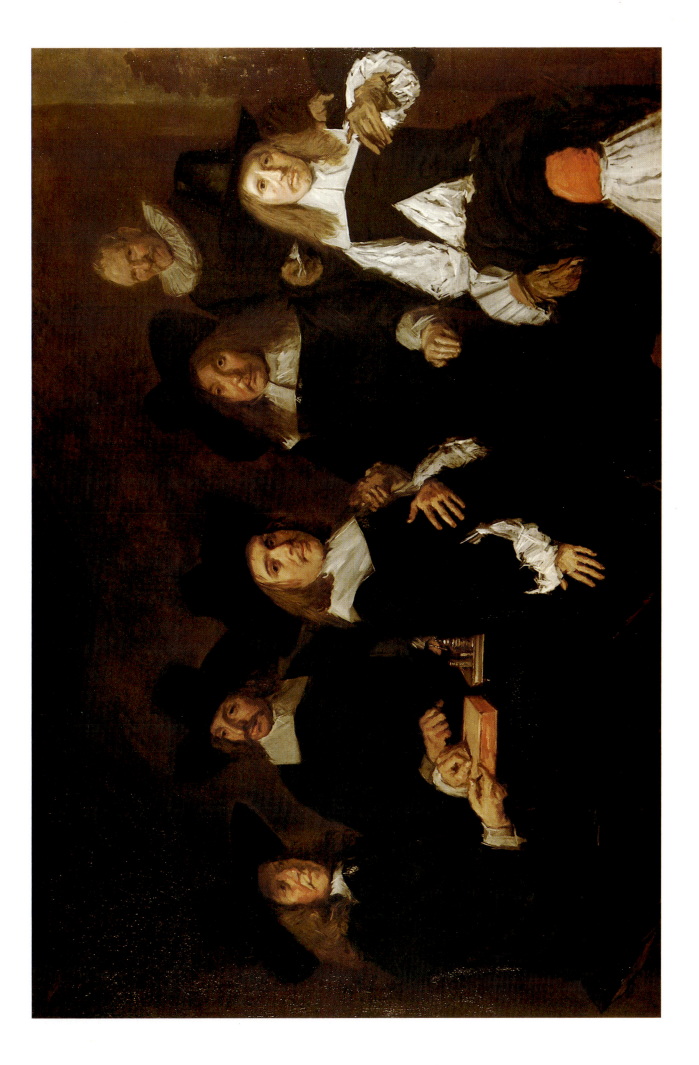

REMBRANDT VAN RIJN (1606 – 69)
Family Group

c.1666–8. Oil on canvas, 126 x 167 cm. Brunswick, Herzog Anton Ulrich-Museum

This family portrait is one of the last pictures painted by Rembrandt. It is undated but must have been made in the last years of his life. It is in his very bold late manner, the paint applied in broad strokes, the surface texture built up with both the brush and palette knife. However, in the faces there is a more careful build-up of layers of paint in which Rembrandt used small brushes to describe the details of the features. There is, as in many of the late works, a concentration upon essentials. The garden setting is indicated in the most rudimentary manner and the mother's skirt is an undifferentiated expanse of warm orange paint. It is interesting to contrast this broad technique with the *Jeremiah Lamenting the Destruction of Jerusalem* of 1630 (Plate 5), with its thin and sparing application of paint onto panel and details scratched into the wet paint with the end of a brush. The portrait of *Agatha Bas* (Plate 14) is equally controlled and precise but later, as in the *Jan Six* of 1654 (Plate 24) and the *Titus* of the following year (Plate 21), the paint layers become increasingly thick with form being indicated by single strokes of a loaded brush. The style of *The Jewish Bride* (Fig. 31) and of the *Family Group* is Rembrandt's last manner in which the depiction of form is almost reduced to two dimensions and there is a delight in the patterns of paint on the surface of the canvas. It was this style that Rembrandt's last pupil, Aert de Gelder, was to adopt and continue to employ well into the eighteenth century. Unfortunately the family have not been identified.

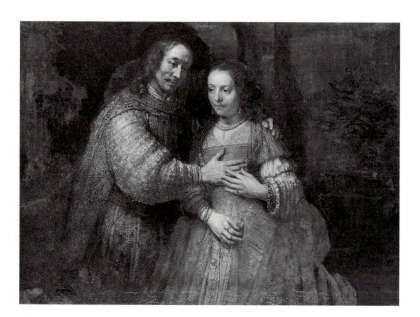

Fig. 31
REMBRANDT
VAN RIJN
The Jewish Bride
c.1665. Oil on canvas,
121.5 x 166.5 cm.
Rijksmuseum, Amsterdam

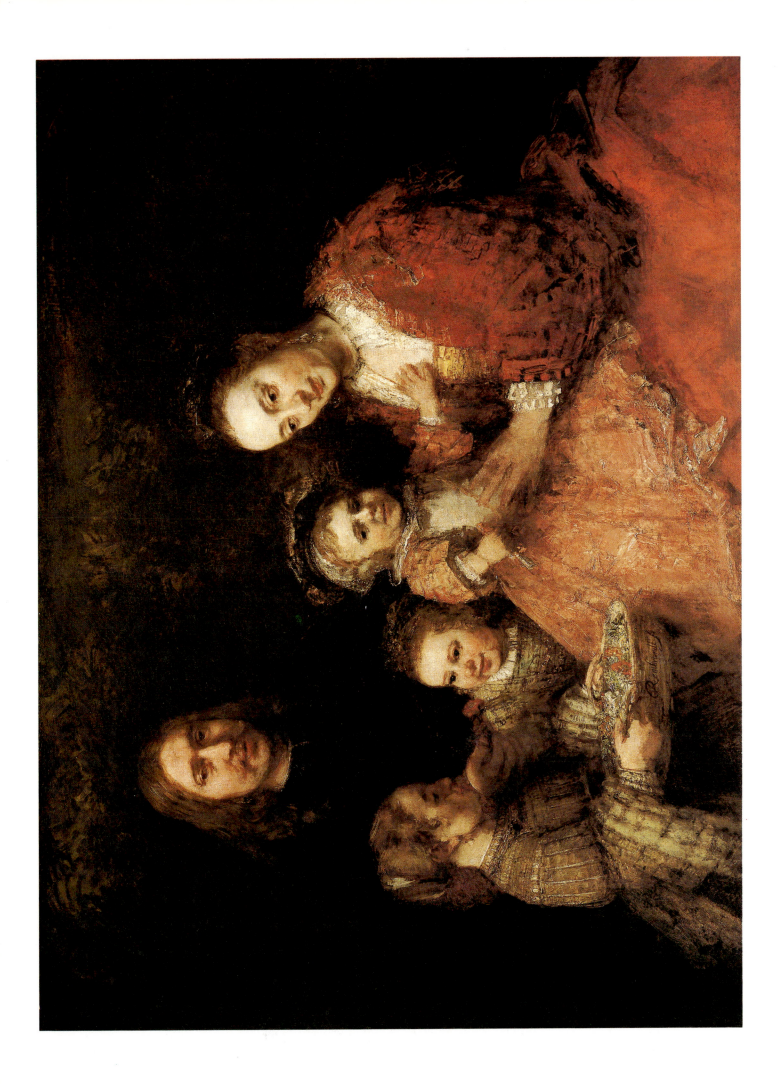

JOHANNES VERMEER (1632 – 75)
The Geographer

1668. Oil on canvas, 53 x 46.6 cm. Frankfurt, Städelsches Kunstinstitut

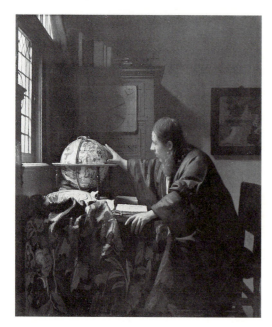

Fig. 32
JOHANNES
VERMEER
The Astronomer
1668. Oil on canvas,
50 x 45 cm. Paris,
Private Collection

This study of a geographer holding his dividers and bent over a map is a pair to a painting in the Louvre which shows an astronomer in his study with his hand outstretched towards a celestial globe. They are exceptional paintings in Vermeer's *oeuvre* as they are the only ones to show single male figures and the only ones depicting scholars. They are recorded as a pair as early as 1713. *The Astronomer* is dated 1668 and so it is reasonable to think that its pendant, *The Geographer*, which bears a signature and date which may not be original, was also painted in that year. The subjects of the two paintings are deliberately contrasted: the study of the heavens and the study of the earth. As it is a celestial globe which is shown in *The Astronomer* we may imagine that it is a terrestial globe which stands on top of the cupboard in *The Geographer*. The celestial globe can be identified – it is a globe first published by Judocus Hondius in 1600 – and the terrestial globe is presumably the one that was published as a pair to it in the same year. The geographer examines a large nautical map on parchment and behind him on the wall is large sea chart of Europe. Vermeer shows the geographer with his head raised from his work, his attention momentarily caught by something in the street outside. The light models his features and throws into sharp relief the folds in his gown. This crisp, linear modelling is characteristic of Vermeer's late style.

JOHANNES VERMEER (1632 – 75)
A Painter in his Studio

c.1666–7. Oil on canvas, 120 x 100 cm. Vienna, Kunsthistoriches Museum

Fig. 33
JOHANNES
VERMEER
Allegory of Faith
1672–3. Oil on canvas,
113 x 88 cm. New York,
Metropolitan Museum
of Art

The artist is seen from behind, seated at his easel, painting a model who is dressed as Clio, the Muse of History. In Cesare Ripa's handbook *Iconologia*, available to Vermeer in a Dutch translation published in 1644, Clio is described as a girl with a crown of laurel, symbolizing Fame, and holding a trumpet and a volume of the Greek historian Thucydides, symbolizing History. The artist is dressed in a deliberately archaic, 'historical' costume. Vermeer's meaning is that History should be the artist's inspiration. Prominent on the wall behind the artist's model, and painted with remarkable precision and delicacy, is a map of the United Provinces. The projection is south to north rather than the west-east projection of modern maps: in the border are views of the principal towns. The painter, Vermeer is saying, will bring fame not just to his country but also to his town. In Vermeer's case, he will bring fame to Delft.

Vermeer made it clear that he was painting an allegorical representation of the studio by the prominence he gave to the curtain which is drawn aside on the left as if to reveal a staged scene. The title is almost certainly Vermeer's own. In the inventory made after his death, the artist's widow referred to the picture as *De Schilderkonst*, 'The Art of Painting'.

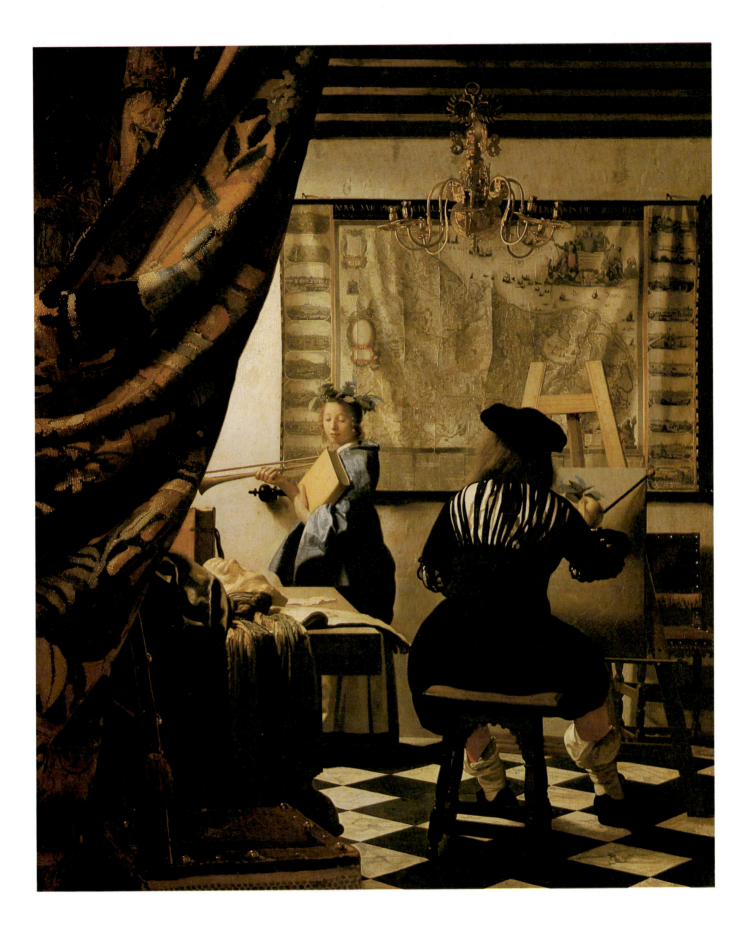

AELBERT CUYP (1620 – 91)
River Landscape

c.1655-60. Oil on canvas, 123 x 241 cm. London, National Gallery

This large canvas, arguably the greatest of all Cuyp's landscapes, was probably painted in the late 1650s, and represents the culmination of his career as a landscape painter. Following his marriage to a wealthy widow in 1658, Cuyp seems to have abandoned painting. Cuyp's patrons, with those of his father, the portrait painter, Jacob Gerritsz. Cuyp, appear to have been members of the regent families of Dordrecht and this landscape, with its remarkable effects of sunlight and the extraordinary delicacy in the treatment of details, was presumably intended to hang in the house of a member of this group which Cuyp joined by marriage. In a print of 1764, made shortly after the painting arrived in England, it is identified as a view of the River Maas at Dordrecht. In fact, it is an imaginary landscape, with mountains on a scale which cannot be found in The Netherlands. Cuyp may, however, have referred to drawings of actual views he made in his sketchbooks, particularly those made on a visit to Nijmegen and Cleves in 1651-2.

The painting was purchased in the United Provinces by Captain William Baillie in about 1760. He acted as an agent for John, Earl of Bute, in the formation of the art collection which hung at Luton Hoo, Bedfordshire. According to Benjamin West, it was this picture which began the rage for landscapes by Cuyp among British collectors. On 18 May 1818, Joseph Farington wrote in his diary: 'I went to the British Institution and there met Mr. West and I went round the exhibition with him examining all the pictures. While looking at Lord Bute's picture by Cuyp, he said that picture was brought to England by the late Captn. Baillie, and was the first picture by that master known in England. Having been seen pictures by Cuyp were eagerly sought for and many were introduced and sold to advantage'.

The painting was purchased from the Marquess of Bute by the National Gallery in 1989.

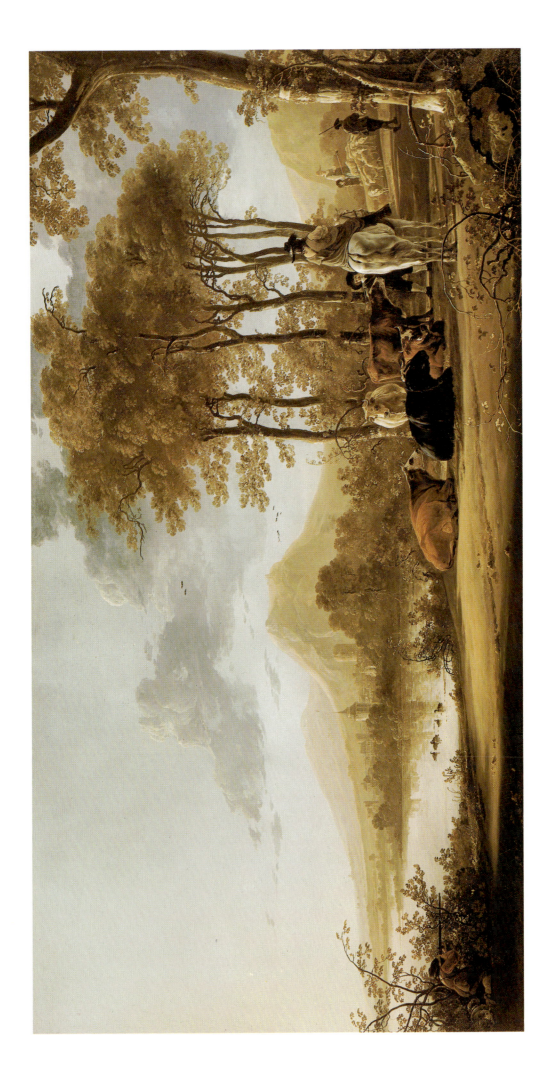

MEINDERT HOBBEMA (1638 – 1709)
Road on a Dyke

1663. Oil on canvas, 108 x 128.3 cm. Blessington, Ireland, Sir Alfred Beit, Bt.

Meindert Hobbema was born in Amsterdam and was a pupil there of the landscape painter Jacob van Ruisdael. Ruisdael had moved to Amsterdam from his native Haarlem by 1657 and Hobbema must have entered his studio shortly thereafter. Hobbema's technique in the depiction of landscape and his choice of forest scenes are derived from his master, but Hobbema's landscapes do not possess the grandeur or the threatening and even melancholy aspect of Ruisdael's. Hobbema's is a reassuringly docile vision of landscape, a town-dweller's account of the beauty of the countryside. It is an essentially decorative view, an anticipation of the rococo landscapes of the eighteenth century. *The Road on a Dyke* shows him placing themes taken from Ruisdael – the pool surrounded by trees, the large over-arching oak dominating the landscape, the country path rutted by the wheels of waggons – in an open, sunlit landscape. The figures and cattle in the right foreground are probably by Adriaen van de Velde, who often collaborated with Hobbema and other landscape painters.

Hobbema's career is a reminder of how precarious a living was to be made from painting in Holland in the seventeenth century. In 1668 Hobbema was appointed to the post of wine-gauger to the Amsterdam guild of wine-importers, through his marriage to the maidservant of a burgomaster in Amsterdam. Although by no means an exalted position, the job did at least guarantee a regular income, and Hobbema almost gave up painting entirely. However, it was during these years that he produced some of his finest works, including *The Avenue at Middelharnis* (Fig. 4), painted in 1689.

NICOLAES BERCHEM (1620 – 83)
Peasants with Cattle by a Ruined Aqueduct

c.1658. Oil on wood, 47.1 x 38.7 cm. London, National Gallery

Fig. 34
NICOLAES
BERCHEM
The Round Tower
1656. Oil on canvas,
88.5 x 70 cm. Amsterdam,
Rijksmuseum

Nicolaes Berchem, the son of a distinguished still-life painter, Pieter Claesz., was born in Haarlem. The town was a leading centre of landscape painting in the early seventeenth century and among Berchem's teachers was the landscapist Jan van Goyen. Like many Dutch artists, Berchem travelled to Italy immediately after completing his apprenticeship. He was in Rome late in 1642 and remained there for three years. While in Italy, Berchem made many drawings of the landscape of the Roman Campagna, its cattle and peasants. On his return to Haarlem Berchem quarried this rich material throughout a long and extremely productive career, painting (and etching) hundreds of Italianate pastoral scenes. As is evident from this painting, he interpreted the Italian landscape and the life of its peasants in an idyllic manner, emphasizing its timeless continuity by the inclusion of antique monuments. These buildings cannot be identified, as they are only loosely modelled on actual ruins. Berchem uses a bright, highly-coloured palette and applies the paint in short, stabbing brush strokes.

In seventeenth-century Holland there was a constant demand for exotic landscapes of this type and Berchem was a highly successful artist. He moved to Amsterdam, which had a larger art market than Haarlem, in about 1677. His work was widely imitated and copied during his lifetime and his paintings enthusiastically sought after in France in the eighteenth century and in England in the nineteenth. This painting, having been in the distinguished Amsterdam collection of Gerrit Braamcamp in the mid-eighteenth century, was bought in Paris by the Duc de Chabot in 1780 and in London in 1840 by Sir Robert Peel.

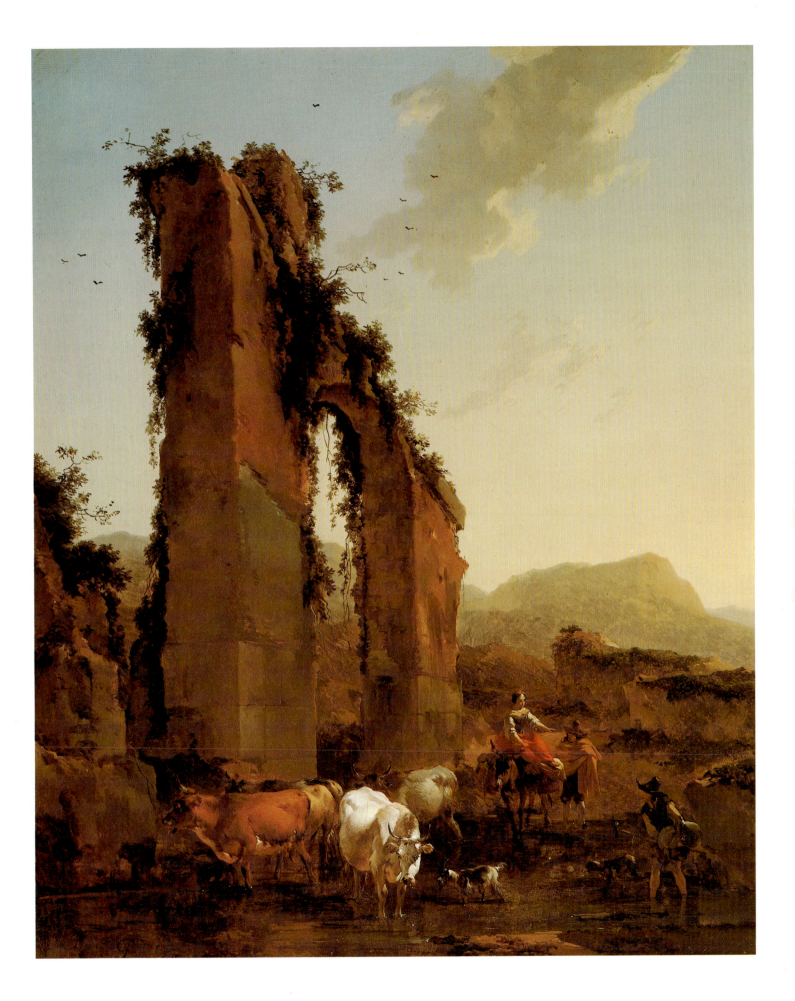

JAN VAN HUYSUM (1682 – 1749)
Hollyhocks and Other Flowers in a Vase

c.1710. Oil on canvas, 62.1 x 52.3 cm. London, National Gallery

Fig. 35
JAN VAN HUYSUM
Flowers in a
Terracotta Vase
1736-7. Oil on canvas
shaped at the top,
133.5 x 91.5 cm. London,
National Gallery

Dutch painters described the visible world with remarkable precision and one of the forms this description took was the still life. In the earliest years of the seventeenth century still lifes often had a vanitas element. Among the apparently random accumulation of objects were clocks, snuffed-out candles, faded flowers and skulls, reminders of the passage of time and the inevitability of death and decay. As the century progressed these elements dropped away and still lifes became simply displays of the rare, exotic, expensive and beautiful.

Jan van Huysum, whose career spanned the first half of the eighteenth century, was the heir to this great tradition of still-life painting and, as far as floral still lifes are concerned, its greatest exponent. This painting is undated but must belong to the first half of his career before about 1720, when he began to paint more elaborate and artificial flower pieces, which are light in tone on light backgrounds, in an almost pastel palette (Fig. 35). It probably dates from about 1710.

Jan van Huysum lived and worked in Amsterdam. He was one of a dynasty of painters, having been trained by his father Justus van Huysum, also a still-life painter, and was later imitated by his younger brother, Jacob.

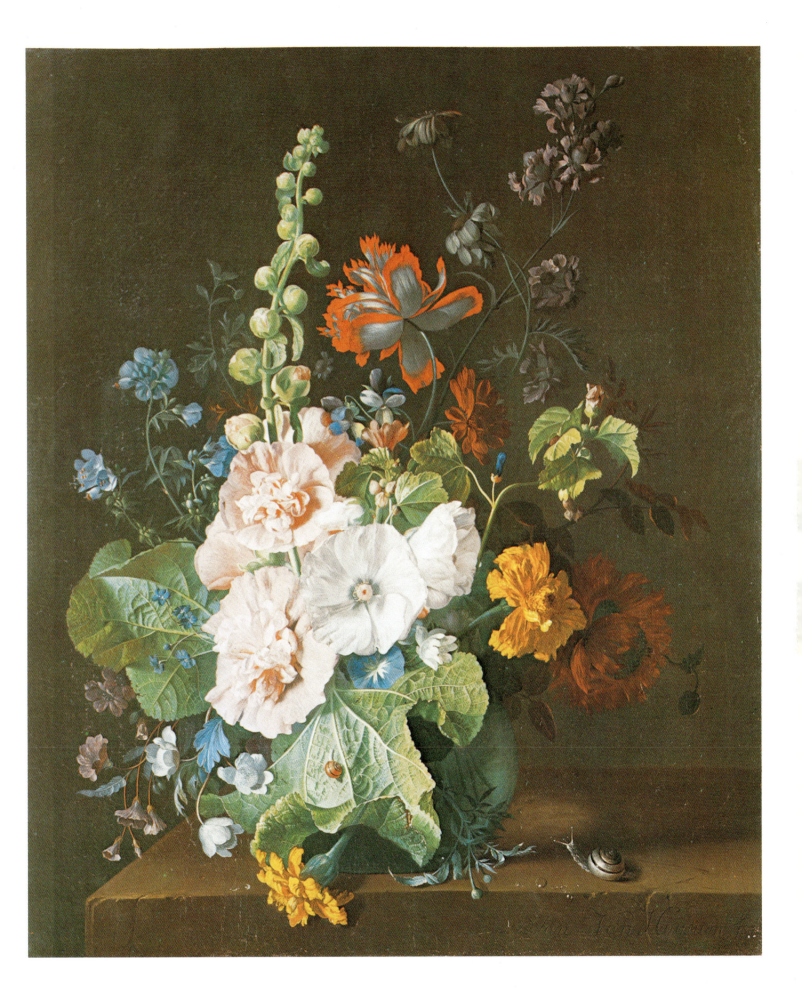

FRANS VAN MIERIS (1635 – 81)
A Lady Looking in a Mirror

c.1670. Oil on wood, 43 x 31.5 cm. Munich, Alte Pinakothek

Gerrit Dou called Frans van Mieris 'the Prince of my pupils'. Van Mieris was the son of a Leiden goldsmith and, like Dou himself, had been trained in the studio of a glass-painter before entering that of a painter. Van Mieris mastered Dou's highly finished technique and after his master's death was the leading exponent of the *fijnschilder* (fine painter) style. He spent his entire working life in Leiden, although (once again like Dou) he enjoyed a considerable international reputation: he received commissions from, among others, Duke Cosimo III de'Medici and Archduke Leopold Wilhelm, who unsuccessfully offered van Mieris the position of court painter in Vienna.

This painting shows the traditional subject of a woman admiring herself in a mirror: in the work of Hieronymous Bosch, for example, it was a symbol of the sin of *superbia* (pride) but by the time it was painted by Gerard ter Borch and van Mieris it simply provided an opportunity for the painter to display his skill in rendering reflections and rich materials. Van Mieris highlights the shimmering satin dress and brightly coloured feather within the dark interior, encouraging the viewer to admire his craftsmanship and virtuosity.

Despite his success van Mieris was constantly in debt and contemporary documents appear to support the accounts of an early biographer, Arnold Houbraken, who described him as a habitual drunkard. He was, however, well respected in Leiden and established a dynasty of painters: his sons, Willem and Jan, and his grandson, Frans van Mieris the Younger, imitated his meticulous style and continued to work in his manner until the 1760s.

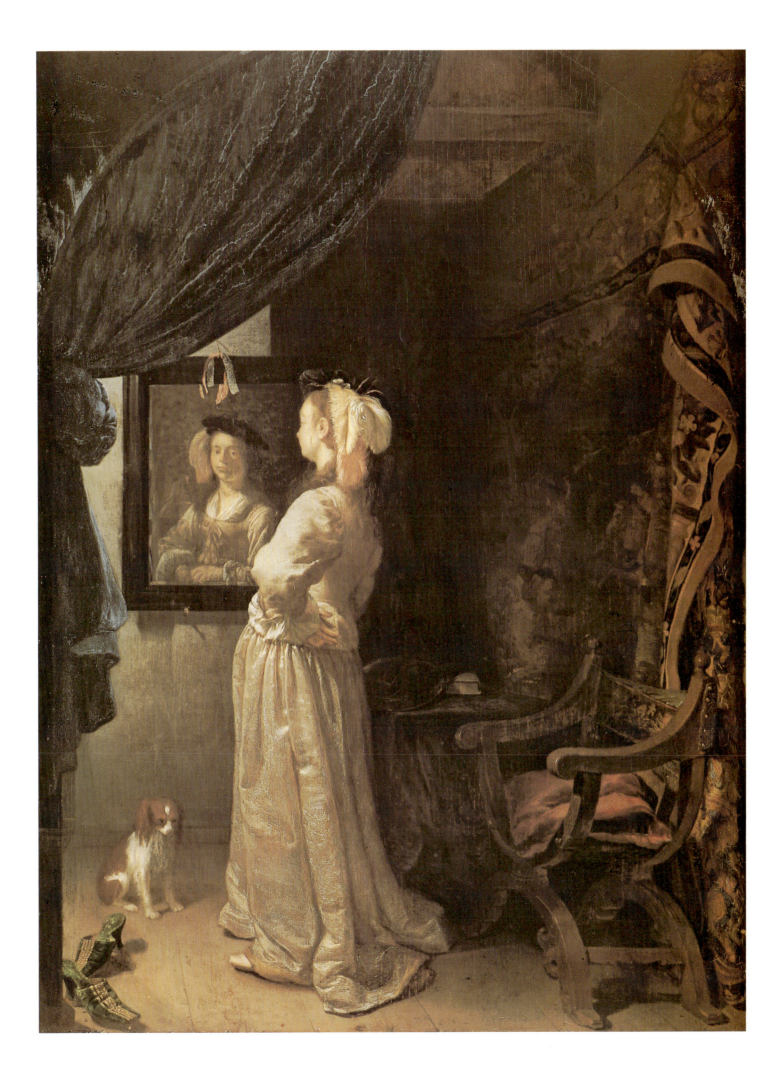